IMAGES
of America

TOGUS
DOWN IN MAINE
THE FIRST NATIONAL
VETERANS HOME

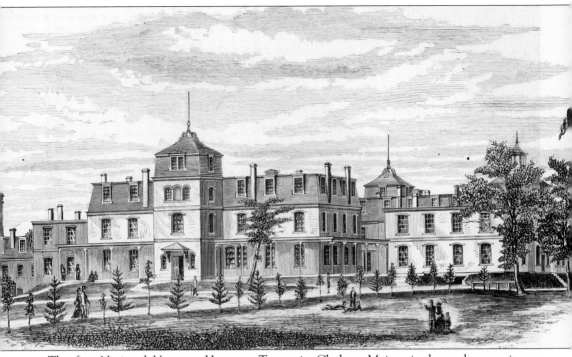

The first National Veterans Home at Togus, in Chelsea, Maine, is shown here as it was completed in 1869. The print is a wood engraving made from a photograph by John S. Hendee as reproduced in James W. North's book, *The History of Augusta*, published in 1870. North described the facilities and the history of The National Asylum for Disabled Volunteer Soldiers at Togus in his book. (TLS)

Throughout the text, certain images are followed with these photograph credits: T.L. Smith (TLS); the Maine Historical Preservation Commission (MHPC); Mathew Brady from the Library of Congress Collection (MBLCC); the U.S. Army Military History Institute (AMHI); Bedford Hayes (BH); the 1878 Annual Report of the Board of Managers (ARBM); the Togus Library (TL); the Boston Public Library Rare Book Collection (BPL); Elmore Morgan (EM); O.R. Cummings (ORC); Robert McDonald (RM); J. Emmons Lancaster (JEL); Maine Historical Society #449 (MHS); Barbara Ballard (BB); Marjorie Brown (MB); Georgia Wiesendanger (GW); Klemen S. Burdzel (KSB); Margaret Stoddard (MS); Roberta A. Cass (RAC); and the *Kennebec Journal* (KJ).

IMAGES
of America

TOGUS
DOWN IN MAINE
THE FIRST NATIONAL
VETERANS HOME

Timothy L. Smith

ARCADIA
PUBLISHING

Published by Arcadia Publishing
Charleston, South Carolina

Printed in the United States of America

Library of Congress Catalog Card Number: 2005936488

For all general information contact Arcadia Publishing at:
Telephone 843-853-2070
Fax 843-853-0044
E-mail sales@arcadiapublishing.com
For customer service and orders:
Toll-Free 1-888-313-2665

Visit us on the Internet at www.arcadiapublishing.com

**Dedicated to James E. Smith
of the 19th Maine Volunteer Infantry Regiment,
my great-grandfather, a disabled Civil War veteran
who was a resident of the National Home at Togus.**

*We came to the graves of those who have fallen in battle,
We come from the city, the mountains and glen;
For those who have fought 'mid the cannon's loud rattle,'
The children are coming, the women and men.*

*We scatter the garlands where comrades are sleeping
'Tis thus that the nation remembers her brave;
Our hearts true to Freedom, like sentinels keeping
Their watch o'er the place where they rest in the grave.*

*We know that no music of ours can awaken
The braves that once fought for our country so dear,
But we think of the days when the nation was shaken
By the tramp of the heroes now slumbering here.*

*The cause that they served will grow stronger and stronger,
For Liberty yet must have greater renown;
And grow in her strength, until time is no longer,
Then live through eternity, wearing her crown.*

*They sleep, but the Nation they valiantly guarded
Now rests from the struggle, both peaceful and free,
These garlands will show how their names are regarded,
While they rest in their graves till the last reveille.*

This memorial hymn was sung on Memorial Day, June 17, 1870, at Togus. It is attributed to the Reverend Moses Kelly, the chaplain at the National Home.

Contents

Introduction

The history of the Togus Veterans Administration Center is one of providing medical services and care to America's disabled veterans since the end of the Civil War. From the time of Jamestown in Virginia and the Pilgrims at Plymouth in Massachusetts, the people of this country have always ensured that those who took up arms for the protection of their fellow citizens would not be forgotten when the battles ended. Men went into battle knowing that if they were killed or disabled, their families and their needs would be provided for by friends and neighbors of the community.

During the Civil War the northern leaders realized that community services for veterans would be overwhelmed by the number of soldiers suffering from wounds, sickness, and disease. Many debates ensued before Congress acted to charter a Board of Managers to open three National Homes to provide uniform care for every Union veteran. The former Togus Spring Hotel in Chelsea, Maine, near Augusta, was being advertised for sale in the *Boston Transcript* during the spring of 1866. The critical need to open a "home" with all due speed probably was the impetus for the Board of Managers to send Gen. Edward W. Hinks to Augusta to view the hotel, out buildings, and land situated at Togus Spring. Within two months of Hinks visit, the land and buildings were purchased for $50,000. The Maine Legislature ceded the land to the federal government and Hinks made immediate plans for the installation of a heating system and modern lighting so that the first veterans could be admitted in November of 1866.

The photographs used in this book have been divided into four chapters that represent different eras at Togus. A sense of what life was like at Togus for the veterans is presented in these photographs, a sense that could not be described by the written word alone.

The Eastern Branch of the National Home for Disabled Volunteer Soldiers at Togus, Maine, set a goal from its inception to help make the home as self-sufficient as possible and to provide a place for the healing of the spirit as well as the body. All officers, staff, and care providers had to be disabled veterans, as mandated by law. Extra pay for work at many different jobs and trades allowed veterans to save enough money to return to their homes and families temporarily, if not permanently. Schooling was encouraged, with classrooms and teachers provided. Religious services were provided by Protestant and Catholic clergy from the surrounding communities every Sunday. A farm was started to help with provisions and provide a sense of self-worth. Concerts and entertainment were a daily part of the homes' routine with visitors encouraged to spend the day and mingle with the members.

By the mid-1880s, Togus was becoming accepted as part of the community of the surrounding villages and cities. Togus veterans received passes to visit the surrounding areas and added to the

local economy. The economic impact on businesses providing supplies and services increased yearly. At the turn of the century Togus became a destination for family excursions.

Improvements to roads from Gardiner and Augusta made it easier for visitors and veterans to travel between the communities. The Kennebec Central Railroad opened in 1890 and in 1900 the Augusta Electric Railway commenced operations. Mainers were on the go and 30,000 to 40,000 visitors descended onto Togus to view theatrical entertainment, musical concerts, picnics and parades, and walked to the "deer park." The large farm was also popular with many city visitors from the early 1900s and until the United States entered into World War I in 1917. Time had taken a toll on many veterans and as the years passed, admission to Togus increased. As family and friends passed on or moved away, the disabled found it harder to sustain their independence. Conditions at Togus were always crowded and many veterans came only as a last resort. Membership peaked in 1904 at over 2,700 veterans and steadily declined as the Union's soldiers died.

Many changes were introduced in the way care was provided for disabled veterans after the Great War of 1917–18. A veteran's bureau was established to handle disability compensation, insurance for servicemen and veterans, family allotment programs for those in the armed services, and vocational rehabilitation for the disabled. At this time, Togus was regulated to hospital services and an "old soldiers home." The number of Civil War veterans continued to decrease dramatically. By 1929 there were about 119 Civil War veterans, 467 Spanish-American veterans, and about 541 World War I veteran residents at Togus. Memorial Day observances, concerts, and baseball were the only occasions that drew a large crowd of visitors during the 1920s. The 1920 U.S. census was the first census to conclude that more Americans were living in urban areas than in rural parts of the country.

The dramatic increase of the automobile and continued improvements in Maine's highways offered people a wider range of choices in selecting destinations for visiting and entertainment. The increased popularity of movies and the radio provided a new source of entertainment for the family.

The Kennebec Central Railroad was closed in June 1929 and the Augusta Electric Railway line followed a few years later. The start of the Great Depression was about to begin.

In July 1930, the Veterans Administration was created by an executive order signed by Pres. Herbert Hoover under laws recently passed by Congress. Congressman John Nelson of Augusta, Maine, began a successful campaign to pass a bill to build a new fireproof 250-bed hospital. A power plant with a 145-foot chimney and a utility building all made of reinforced concrete with brick facing were added to the original bill by amendment. Construction was started in May 1932 and completed the following year.

Togus played a small part in helping to ease the severity of the Great Depression in the Augusta and other area communities by employing 320 full-time employees. In 1939 it had a yearly payroll of $475,000. Between 1932 and 1960, over 60 wood buildings and sheds were demolished and replaced with a modern complex of brick-face buildings that provided Togus with the basics to continue its mission in post-World War II America. The mission had changed from home to hospital and rehabilitation of our veterans.

With the end of WW II in 1945, virtually every person's life was affected. Similar to reactions after the Civil War, many individuals and organizations were created to help provide adjustments to this country's returning disabled veterans. Individuals who retired from Togus over the years returned to volunteer their services wherever needed. The forgotten war heroes from the Korean Conflict added to the population at Togus in the mid-1950s and beyond. The historical significance of Togus to our nations armed service veterans has largely remained unnoticed and it is my desire that this book of photographs will both entertain and inform the readers about a time and place that no longer exists as it once did a long time ago.

—Timothy L. Smith

Bibliographical Note

In 1966, Allen W. Squires made a successful effort to compile a history of Togus called *History of Togus: First Hundred Years*. Much of the data for the book was found by searching the microfilm editions of the *Kennebec Journal* and the annual reports submitted to Congress by the Board of Managers for the homes.

The best sources are those yearly reports, which are printed in the miscellaneous documents of the House of Representatives for each Congress. The social history of Togus can be found in three descriptive guides to Togus. The first is *History and Description of the Eastern Branch of the National Home for Disabled Volunteer Soldiers Near Augusta ME*, written by W.S. Whitman, a Civil War veteran and resident of Togus in 1879. Whitman's 78-page guide includes statistics gathered from early annual reports to the Board of Managers. In 1886, Henry O. Spalding, a resident of Togus, published an 18-page guide entitled *A Sketch of the Eastern Branch Home DVS Togus, Maine*. Daniel W. Robinson wrote a brief, comprehensive, 60-page description of how the home was managed, entitled *Robinson's Descriptive Guide to the Eastern Branch, N.H.D.V.S., Togus, Maine*, which was published in 1894. These three books are indispensable to understanding the early years at Togus.

Three other pamphlets that present an alternative view of Togus are worth pursuing. A 14-page pamphlet, by an unknown author, entitled *Another Hot Shot Against the Corruption and Tyranny of Luther Stephenson, Governor of the National Home at Togus from 1883–1897*, published in Boston in 1897, makes several serious charges against Governor Stephenson. A pamphlet entitled *Pension Reform as Viewed at the N.H.DVS*, published about 1890 by W.G. Haskell, describes the effects of amendments to existing pension laws on the Togus pensioners. In 1895, a pamphlet published by the *Togus Syndicate* entitled *Attention, Comrades! Plain Facts in Relation to the Management of the Solders' Home, Togus Maine*, alleges cruelty and mistreatment of some veterans, along with misappropriation of funds from the Commissary Department.

An investigation of the National Home for D.V.S. in 1884 by a House of Representatives committee offers a balanced look at Togus and other National Homes. The best recent study of the early history of all the National Homes is *Creating a National Home Building the Veteran's Welfare State 1860–1900*, by Patrick J. Kelly, published by Harvard Press in 1997.

Between 1895 to 1915, at least five booklets with photographs or photographs and drawings of the buildings and people at Togus were published. In the order of their publication dates they are as follows: *View of the Eastern Branch National Home for Disabled Volunteer Soldiers, Togus Maine*, ca. 1896; *National Home D.V.S Togus Maine* ca. 1904; *Eastern Branch National Home D.V.S. Togus Maine* ca. 1906; *Eastern Branch National Home D.V.S. Togus Maine* ca. 1908; and *Souvenir Veins of National Soldiers Home Maine*, ca. 1915.

In 1997, the author wrote a research paper on the history of Togus entitled *Togus: Down in Maine: The Creation of the First National Home for Disabled Volunteer Soldiers, 1866–1869* and a copy was deposited at the Togus Veteran Administration Center library. The 25-page paper was thoroughly researched and included a comprehensive bibliography.

Finally, Donald Beattie, a retired history professor residing in Winthrop, Maine, is currently researching the history of Togus and he hopes to have a thorough history of Togus ready for publication within two years.

One

Creating the Nation's First Veterans Home

1866–1883

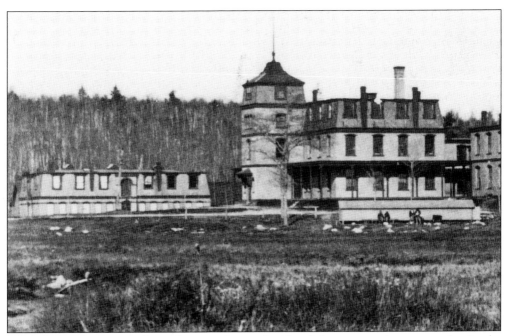

These four veterans sun themselves on the south side of the veterans home complex in the spring of 1872. The brick building on the left contained a machine shop on the first floor and a shoe shop and tailor's shop on the second floor. (MHPC)

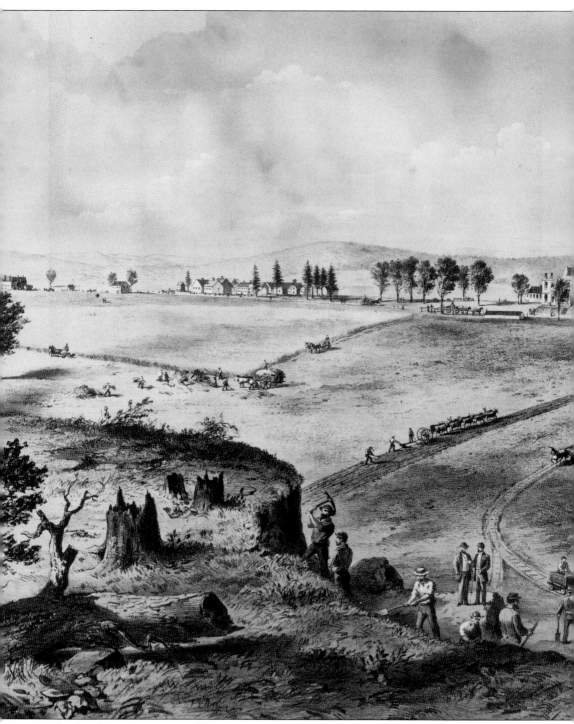

The first known overview of the National Soldiers Home was drawn by John B. Bachelder in 1872. The activities shown illustrate what a visitor to Togus might encounter while touring the buildings and grounds. At the far left is the brick cow barn. In the middle of the farm buildings is the farmhouse of the original settlers of this area. In the center of the lithograph stand the

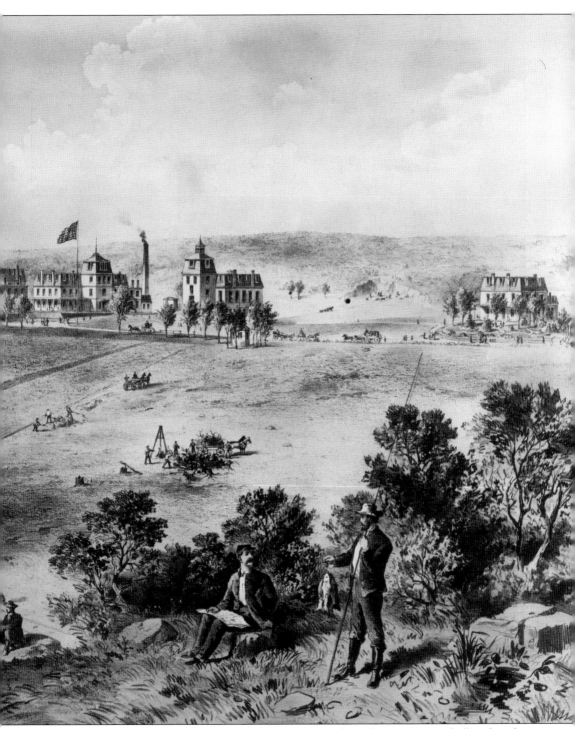

four barracks set in a quadrangle. To the right of the barracks is the amusement hall and to the far right the deputy governor's residence. Bachelder was an early photographer and artist from New Hampshire who drew many bird's-eye views of New England towns and cities during the 1850s. (TLS)

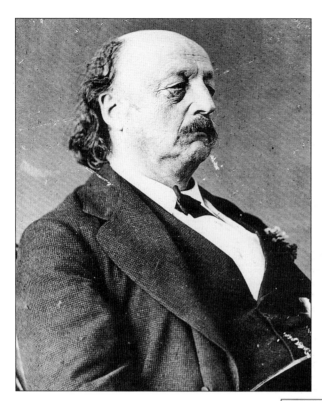

Benjamin F. Butler was the moving force and president of the Board of Managers who created the first National Asylum for Disabled Volunteer Soldiers at Togus, Maine, in 1866. Butler was born in Deerfield, New Hampshire, and moved to Lowell, Massachusetts, with his widowed mother in his youth. Butler graduated from Colby College in 1838 and was a lawyer and representative in the Massachusetts Legislature, prior to enlisting in the Union army and attaining the rank of general. (MBLCC)

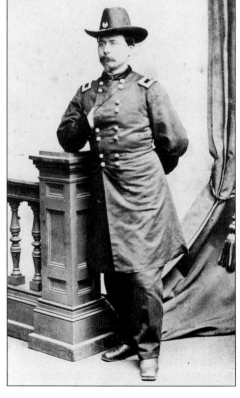

Gen. Edward W. Hinks was the first governor of the three national homes built after the Civil War. A native of Belfast, Maine, Hinks moved to Boston and was elected to the Massachusetts House of Representatives in 1855, where he became friend and protégé of Benjamin Butler. Hinks visited and recommended purchasing the vacant resort and the land and buildings were bought in the summer of 1866 for $50,000. (AMHI)

The second amusement hall at Togus was completed in 1872 after fire destroyed the first building. This handsome brick building with mansard roof was painted a sandstone color. The newly planted trees and absence of evergreen trees near the slope of the building indicate this photograph was taken in the early spring of 1872. (MHPC)

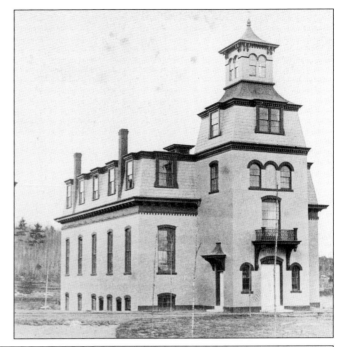

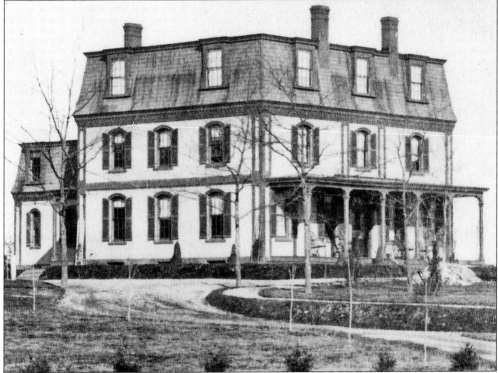

This residence housed the deputy governor of the National Home for Disabled Volunteer Soldiers at Togus who served as the administrator of the Eastern Branch. The brick house was built in 1870 and occupied by Deputy Gov. William Tilton during that summer. Some of the young trees shown in this *c.* 1872 photograph are still standing after 126 years. (MHPC)

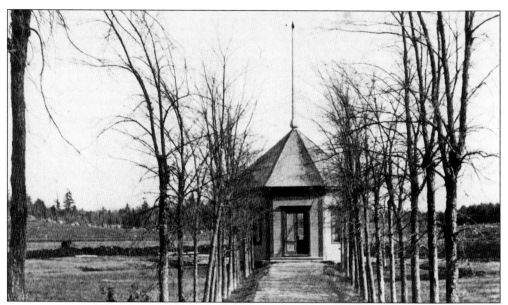

The octagon shelter is located over the spring that gave Togus its name. The Native Americans who lived in the area called the spring "Worromontogus," meaning "strong medicine water." It was not until 1810 that local residents discovered the sulfurous mineral spring, located in what later became Chelsea, and shortened the name to Togus. The building, boardwalk, and trees beside the walkway were constructed by Horace Beals at the same time he built the hotel and outbuildings for his grand resort. The mounds of dirt located in the center background are from an attempt to create a channel to drain the low lying marsh area to make it better suited to growing hay. (TLS)

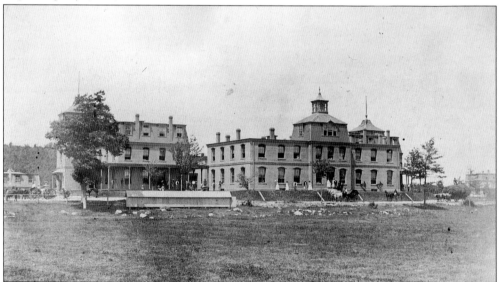

A warm summer afternoon about 1870 finds a large group of visitors and Togus veterans posing for an unknown photographer. The steam fire engine *General Butler* is at the far left, with the two-story shoe shop building in the background. Several visitors with children are near the main entrance of the administration building, while at the far right is the newly completed residence of Deputy Governor Tilton. (BH)

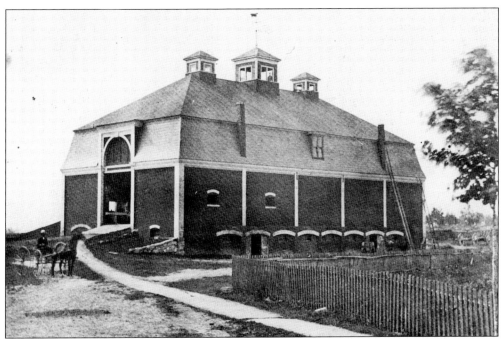

The massive brick barn at Togus, *c.* 1872, was run by veterans and hired farmhands. The 97-by-48-by-24-foot structure was built in 1869 at the cost of $5,000 using bricks made on the premises. General Tilton, deputy governor of Togus from 1863 to 1883, was noted for his interest in farming and greatly improved the breeds of the farm animals. (MHPC)

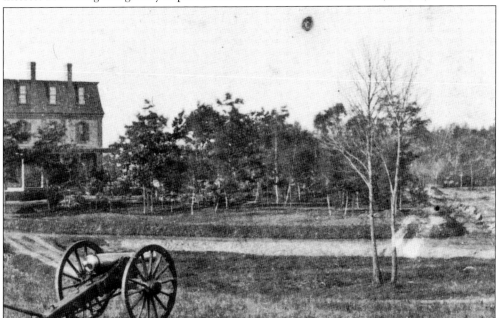

A shiny, brass 12-pound Napoleon field artillery cannon rests in front of the deputy governor's residence *c.* 1878. The small trees have grown several inches in diameter since the photograph on p. 9 was taken. On the right is the road to the north entrance of Togus that leads to Route 17. (TLS)

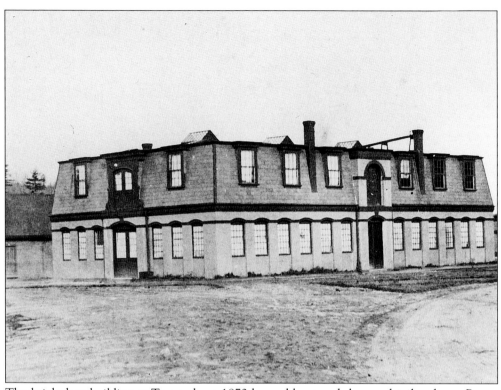

The brick shop building at Togus about 1872 housed boot and shoe and tailor shops. Power was supplied by a steam engine, and manufacturing began in June 1870 and operated for five years before closing due to financial losses. It reopened about 1879 with outside civilian management but failed to produce the quantity needed to yield a profit and was closed permanently in 1883. (MHPC)

Bill of fare.			
Days.	**Breakfast.**	**Dinner.**	**Supper.**
Sunday	Pork and baked beans, brown bread, butter, coffee.	Corned beef, cabbage and potatoes, or bread-pudding, bread, coffee.	Prunes or crackers, bread, butter, tea.
Monday	Mackerel, potatoes, bread, butter, coffee.	Boiled beef, vegetable soup, bread, molasses.	Apple-sauce, bread, butter, tea.
Tuesday ...	Meat, hash, bread, butter, coffee.	Roast beef, pickles, potatoes, bread, tea, molasses.	Ginger-bread, bread, butter, tea.
Wednesday.	Eggs or fish, hash, bread, butter, coffee.	Shoulder or corned beef, potatoes, cabbage, bread, tea or coffee.	Apple-sauce or prunes, bread, butter, tea.
Thursday ..	Baked beans, bread, butter, coffee.	Roast beef or fried sausages, pickles, bread, potatoes, coffee, molasses.	Crackers or cheese, bread, butter, tea.
Friday	Mackerel, potatoes, bread, butter, coffee.	Fresh fish or clam-chowder, potatoes, bread, molasses.	Ginger-bread, bread, butter, tea.
Saturday...	Meat, hash, bread, butter, coffee.	Roast mutton, potatoes, coffee or mutton stew, bread, molasses.	Cheese or crackers, bread, butter, tea.

Tea time at the Togus Mess Hall in 1875 was a light meal served in the evening. The bill of fare for Togus in 1877 was plentiful, although it varied little from one season to the next. The average cost for a meal was 22¢, with special diet items available for the sick. The veterans complained that they could tell the day of the week by the meal before them. (ARBM)

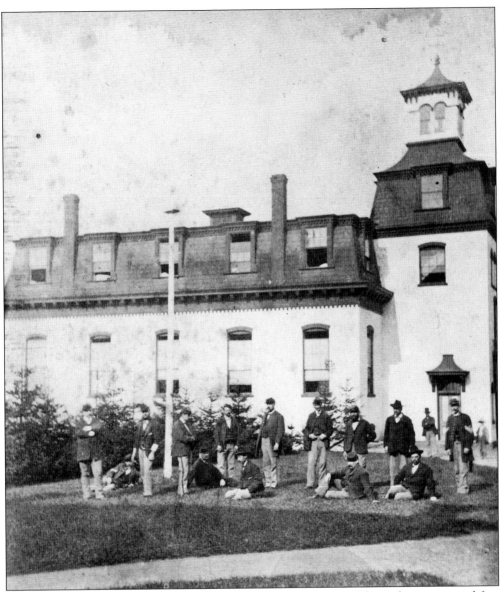

A group of veterans pose beside the amusement hall about 1880. The auditorium seated five hundred people. The basement of the building housed a billiard room, guardhouse, and quarters for police, while the third floor was used as a dormitory. A theater company from Augusta was the first outside group to perform at the amusement hall and their October 21, 1872 performance of *Aunt Charlotte's Maid* was warmly received in the packed auditorium, which continued to host performances until the opera house was built in 1893. (MHPC)

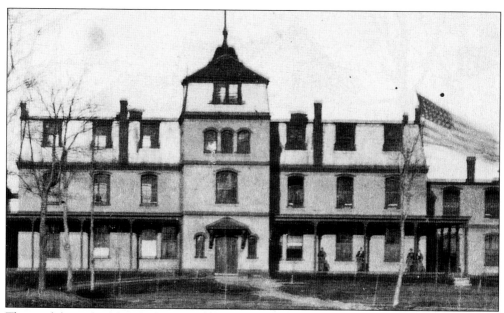

The south barrack of the quadrangle is pictured here about 1872. The center tower contained the entrance and stairs that led to the officers' quarters, barracks for the veterans, dining room, kitchen, post office, telegraph office, and library. A piazza ran along the entire building. (MHPC)

The south end of the quadrangle's west barrack is pictured here about 1872. The basement of the quadrangle contained the wash and bathrooms, laundry, boiler room, storage areas, and the bakery. The kitchen and a serving room was on the first floor of the ell, while the bathroom, steward's chamber, and store rooms were in the basement. The hospital was located on the second floor of the ell. (MHPC)

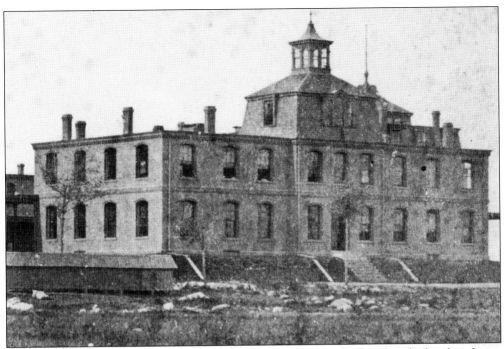

This 1872 picture is of the eastern barrack of the quadrangle. The first floor had a chapel, two school rooms, a kitchen, dining room, bedrooms, and parlors. The second floor was used as barracks. A third-floor mansard roof was added to the east and west buildings by 1878. (MHPC)

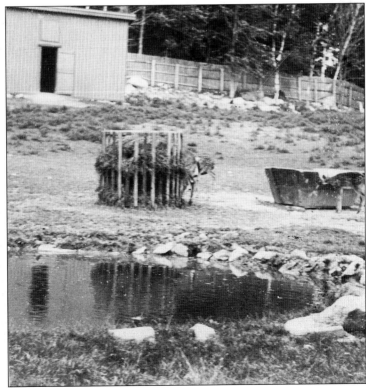

The Togus "deer park," c. 1880, was located on the site of the current hospital. The park was created in the mid-1870s for the amusement of the residents and visitors. The photograph shows three deer at the feeding area with a shelter and store house in the background. (MHPC)

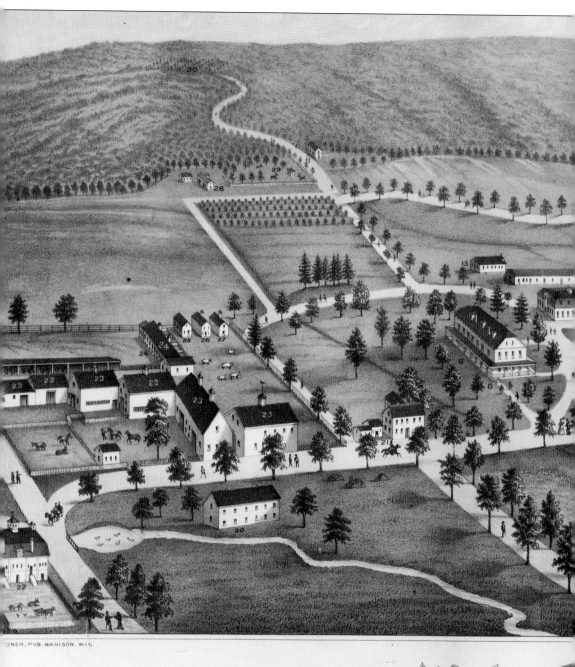

1 GEN.W^M S.TILTONS.RES.DEP^T GOV.
2 CO.D BARRACKS
3 CO.A
4 CO.E
5 CO.B
6 HOSPITAL
7 AMUSEMENT HALL
8 BOOT & SHOE SHOP
9 DINING ROOM & KITCHEN
10 ENGINE ROOM & LAUNDRY
11 GAS HOUSE
12 STORE HOUSE
13 CARPENTER SHOP
14 BOWLING ALLEY
15 BAND STAND
16 RESERVOIR

NATIONAL S

TOGUS . NEAR . A

BIRDS EYE VIE

A wonderful bird's-eye view of Togus drawn by Albert Rugar in 1878 shows the many new

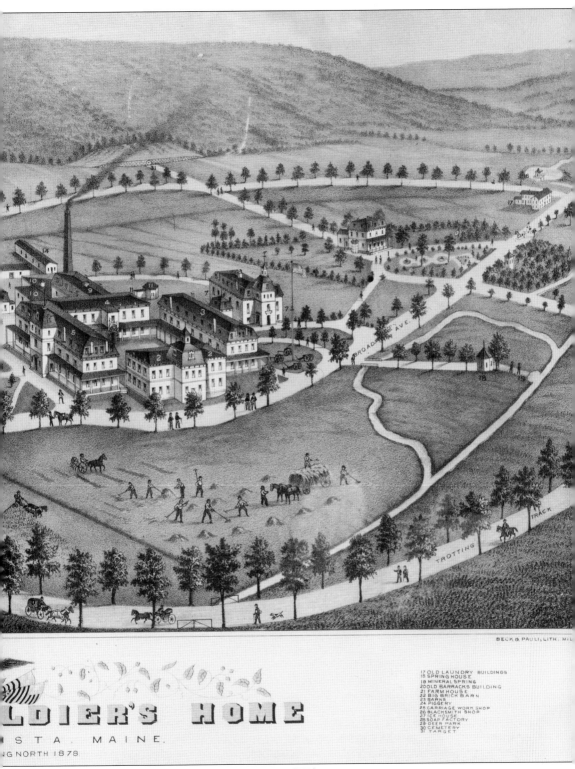

17 OLD LAUNDRY BUILDINGS
18 SPRING HOUSE
19 MINERAL SPRING
20 OLD BARRACKS BUILDING
21 FARM HOUSE
22 BIG BRICK BARN
23 BARNS
24 PIGGERY
25 CARRIAGE WORK SHOP
26 BLACKSMITH SHOP
27 ICE HOUSE
28 SOAP FACTORY
29 DEER PARK
30 CEMETERY
31 TARGET

LDIER'S HOME

STA. MAINE.

NG NORTH 1878

buildings and improvements created since 1872. (TL)

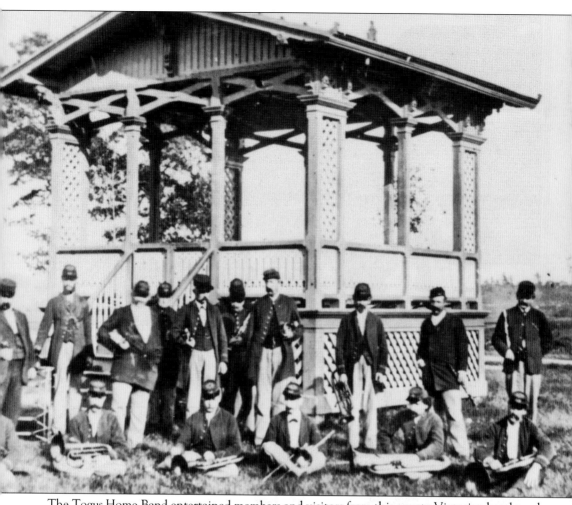

The Togus Home Band entertained members and visitors from this ornate Victorian bandstand until 1892, at which time a new bandstand was constructed. The band was formed shortly after the National Home at Togus was opened in 1866 and its first noted public appearance was in Augusta, Maine, on October 4, 1867, at Granite Hall. After the band's instruments were destroyed in a fire in January 1868, the Augusta Cornot Band gave instruments in March of that year to the grateful members at Togus. (TLS)

Two

The Veterans Home
Becomes a Community

1884–1918

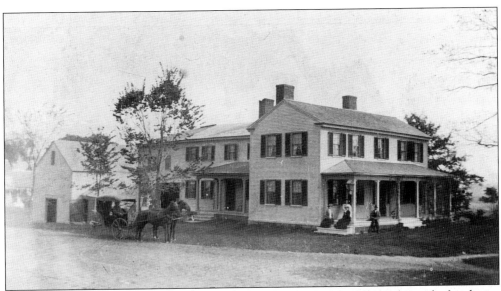

James and Joseph White were probably the builders of the main Federalist-style farmhouse in the mid-1830s, while the porches and the left section of the ell were later additions to accommodate the female nursing staff for use as dormitories. A wealthy New York businessman, Horace Beals, purchased the spring, surrounding land, and buildings in 1858 and constructed the Togus Spring Hotel in 1859, but it closed in 1861 due to the Civil War. The photograph is c. 1900. (TL)

TOGUS, DOWN IN MAINE.

An Old Soldier's Refrain.

Air: Bingen on the Rhine.

The soldiers of the Union upheld the Nation's rights,
And earned the country's gratitude in many bloody fights;
By minie, shell and grape shot were half a million slain,
And part the last survivers are at Togus, down in Maine.

We rallied to the bugle, on duty night and day,
Fighting for home and country—not thirteen dollars pay;
So, injured in the service, our Union to maintain,
To mend our constitutions, we are at Togus, down in Maine.

For us our home was builded, that we may live at ease.
Have decent food and clothing, the blood-bought fruits of peace.
The surgeon looked us over and said we might remain
Till Gabriel blows his trumpet at Togus down in Maine.

When we arrived at Togus we found a well kept house,
They dress us all in uniform, an overcoat and blouse,
They give quinine and whiskey to ease us of our pain,
And take best care of soldiers at Togus, down in Maine.

Twelve hundred war-worn soldiers, away "down east" we stay,
By Uncle Samuel boarded since done our fighting day;
Wheat bread and beef is plenty, no reason to complain,
Our home is very pleasant at Togus, down in Maine.

At half past nine we all "turn in," at six we all "turn out,"
We give our beds a shaking, and proceed on our route;
We take a cold ablution, and then we fall in line,
To get our hash and coffee at Togus, down in Maine,

The Sergeant makes a detail to go upon fatigue,
Sweep walks and peel potatoes, and thro' the winter's siege
The snow a hundred shovel the paths across the plain,

Reading-room and library and minstrels to amuse,
On Sunday, chapel service for Christians, Greeks and Jews;
Ten-pins, old sledge and billiards, and many a pleasant game,
Fills up our idle hours at Togus, down in Maine.

When the coachman, Morey, brings the frequent mail,
There's rushing for the missives from friends beyond our hall;
Sometimes the "Bells of Togus" rolls to meet the train,
And brings the Board of Managers to Togus, down in Maine.

Gen. Stephenson is a hero, he drew a trusty blade,
In the war for home and country a gallant fight he made;
A scar upon his face shows that he suffered pain,
And now he heads our numbers at Togus, down in Main.

Our treasurer is substantial, at least he is no myth,
A gallant, courteous gentleman is Col. A. J. Smith;
He has charge of all the moneys, and without thought of gain,
Watches the soldiers' interest at Togus, down in Maine.

Dr. Bolan is our surgeon, a gentleman of skill,
He looks after his old comrades with ipecac and pill,
Aided by his assistant, who we must explain,
Is not the "fat boy in picwick," but genial Dr. Lane.

The ladies of the Home must be mentioned here,
They cheer us with their presence, without them 'twould be drear.
They do not meet us with a cold disdain,
We're not charity paupers at Togus, down in Maine.

The Home belongs to soldiers, though citizens may howl,
We have not faced the canon to be frightened by an owl;

...we're pleased to have you see us, so do not constrain
To view retired soldiers at Togus, down in Maine.

Our time is all a holiday, we're done with toil and strife,
And the Nation's bounty gives longer lease of life;
The Fourth and Memorial we dream of war again,
Although we are disabled at Togus, down in Maine.

We're on life's latest marches and getting short of breath,
Enlistment almost over, we're mustered out by death;
Escorted to the hillside, the stars and stripes are lain,
To mark the soldier's resting place, at Togus, down in Maine.

Please do buy this song, a help it will prove to be
For one who has, at his command, a family;
A soldier poor I am, and never free from pain,
All the way from Togus, down in the State of Maine.

The story we have told you, the song we hope you'll share,
The band plays us the music nearly in the square;
And now my tale is ended, you will not think me vain,
I'm a disabled soldier at Togus, down in Maine.

DAVID D. GILSON, FIRST MASS. REGIMENT, H. A.

The Soldier will nus as a mortal or work again—
They mean we shall be gentlemen at Togus, down in Maine.

A pretty place is Togus, with everything to cheer,
For Temperance and health the Sulphur Spring is here;
We well may be contented, we to ourselves explain,
To live and die at Togus, our last retreat in Maine.

Deers in the park are pretty, pretty deers in Gardiner, too;
Jack Hart's peer is not so dear, but many make it do;
Beware of bogus whiskey, 'tis bad for bone and brain,
Keep "right side up with care," sir, at Togus, down in Maine.

On pleasant winter evenings we have a social dance,
While ladies in our ball-room in rythmic maze advance;
Soldiers all are gallant to the fair who deign
To trip the light fantastic at Togus, down in Maine.

Polish your boots and buttons once a month with vim,
Be ready for inspection in military trim;
Sleep never in the saw-mill, for you will nothing gain
By acting like a bummer at Togus, down in Maine.

I was in Co. M. 1st Mass. H. A.; one of Gen. Hancock's veterans. Served 3 years, 2 months, 14 days in the army, and served 6 months in Libby Prison. Enlisted when only 14 years old; nothing but a boy.

PLEASE BUY MY SONG AND HELP THE OLD SOLDIER ALONG.

PRICE ONLY 5 CENTS.

PLAIN WASHING AND CHAIRS RESEATED AT 36 MULBERRY STREET, BY MRS. GILSON.

Togus, Down in Maine was written about 1884 by David D. Gilson, a veteran of Company M, First Massachusetts Heavy Artillery. Gilson apparently sold copies of the broadside for 5¢ to earn spending money. Several years later, authorship was claimed by John H.P. Gould of the Sixth Massachusetts Volunteers. The later copy is located at Widener Library, Harvard University. (BPL)

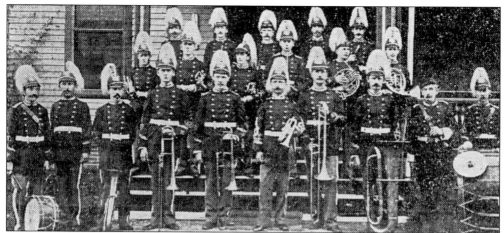

The Togus Home Band in 1887 became well known under the direction of Prof. Berthold W. Thieme, shown sixth from the left in the front row. Pictured and listed from left to right are as follows: (front row) Mr. Folsom of New Hampshire (#1), Al Noland of Boston (#3, considered one of the best orchestra and band players of this area), Archie Bridge Cony (#4), Eli Aiken (#5), and Julius Gross (#8); (middle row) Frank Howe (#5, later a band leader in World War I) and Bert Roundy (#5); (back row) John Barrett (#3, of Boston) and Thomas Phasey (#4). (TL)

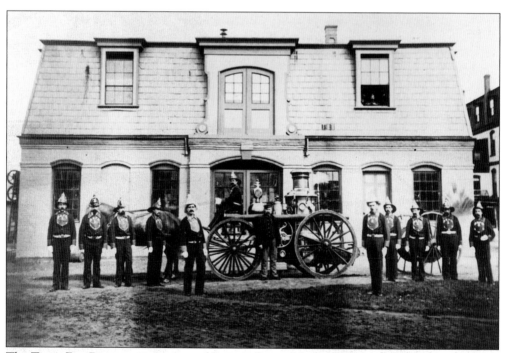

The Togus Fire Department is pictured here in front of the work shop around 1885, with their new twin-cylinder steam fire engine with all the latest improvements built by the Amoskeag Works in Manchester, New Hampshire, and affectionately referred to as "General Butler." Listed from left to right are Henry C. Raymond, Ames S. George, Robert H. Black, Samuel Roberts, Foreman John R. Leslie, Driver Lewis Bird, Engineer Burns, Assistant Andrew Jackson, Alfred Johnson, Stephen Doyle, Peter Nveau, and John W. Moutin. (MHPC)

Gen. Luther Stephenson became deputy governor of Togus in April of 1883. Stephenson tried to instill his strong moral beliefs and practices in the veterans at Togus. He was a hard-edged disciplinarian who was disliked by many residents, including most officers. In 1897, Stephenson resigned from Togus, believing that whatever he had done was in the best interest of his charges. (AMHI)

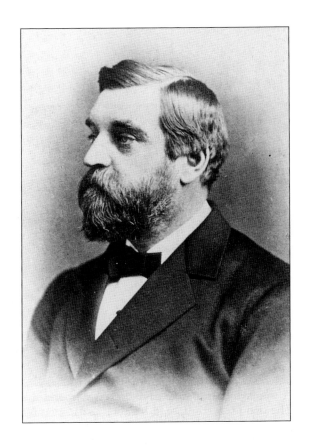

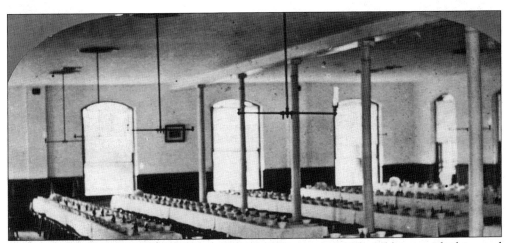

The main dining room at Togus is prepared for the next meal with the tables set with china and flat ware in the 1880s. The pipes suspended from the ceiling mounted gas lamps to illuminate the hall. A gas-making machine was located in the attic where air was mixed with vapor from a volatile and combustible petroleum product called gasoline. The gas flowed by gravity to all the light fixtures. (MHPC)

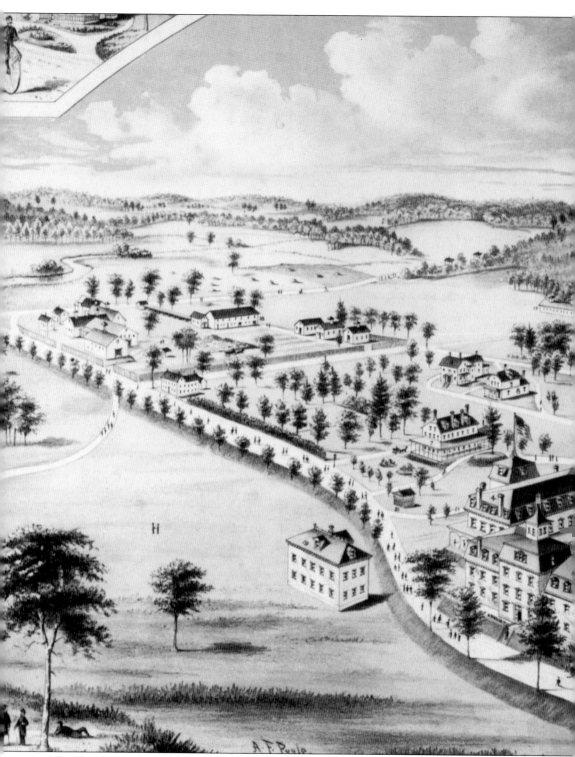

This detailed bird's-eye view of Togus was drawn in 1885 by Albert F. Poole, who maintained a studio on Monhegan Island. Togus in 1885 continued to expand with new buildings and

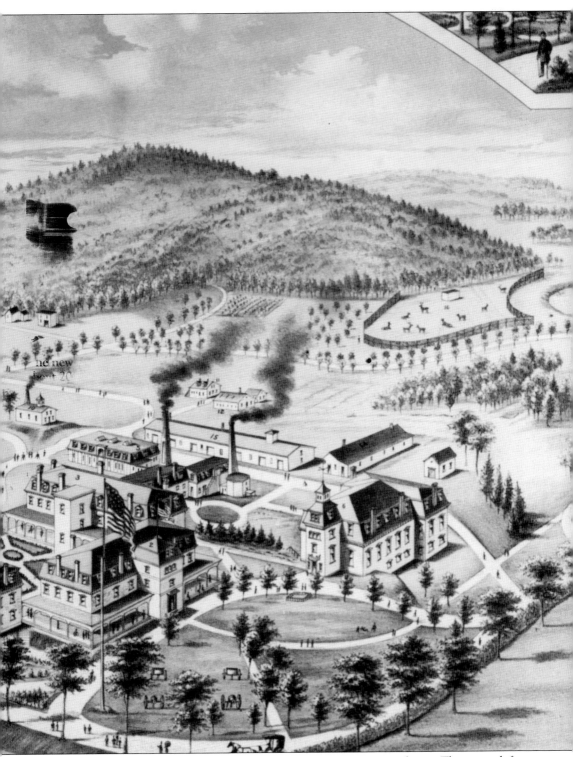

veterans. As of December 31, 1884, there were 1,267 veterans in residence. The upper-left-hand corner shows a brave soul on a bicycle. (TL)

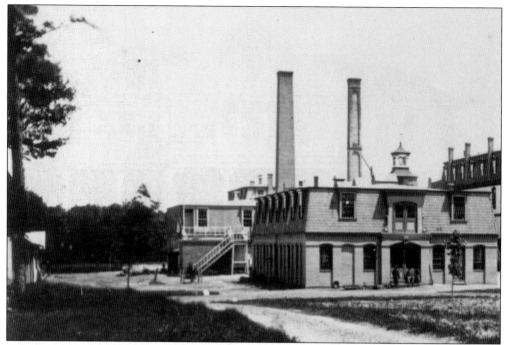

The Togus machine shop building is pictured here about 1883, the same year that the boot and shoe manufacturing operation closed permanently. The second floor of the building was then converted into a dormitory. The two-story brick building in the rear of the shoe shop is an addition to the hospital built in 1870. (EM)

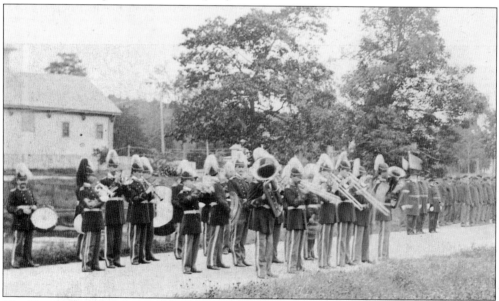

The Togus Home Band played here at what may have been a Fourth of July ceremony. The first officer to the right of the band is Col. S.H. Allen, governor of Togus from 1897 to 1905. Gen. John T. Richards succeeded Allen, who resigned because of poor health. Richards was the brother-in-law of Laura E. Richards, Pulitzer-prize winning author and long-time patron of the Gardiner, Maine, arts. (George A. Paige Photograph, TL)

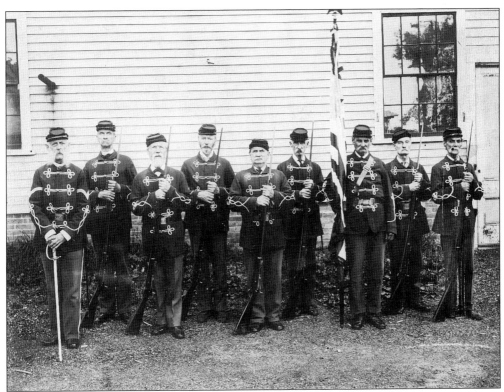

The Togus Firing Squad performed at funerals, parades, and other ceremonial functions. A note on the rear of the photograph states, "My cap shades my face, I don't like it, Makes me look old." (TL)

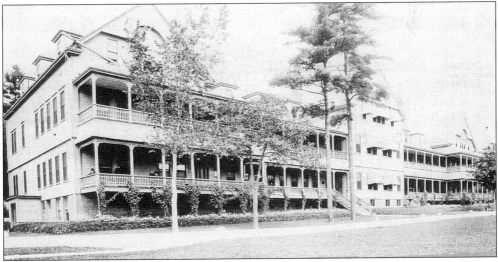

The new main hospital on Rockland Avenue was built in 1891 and contained 16 wards and 300 beds when this c. 1893 photograph was taken. The hospital laundry, autopsy room, morgue, and wine cellar were located in the basement. (TLS)

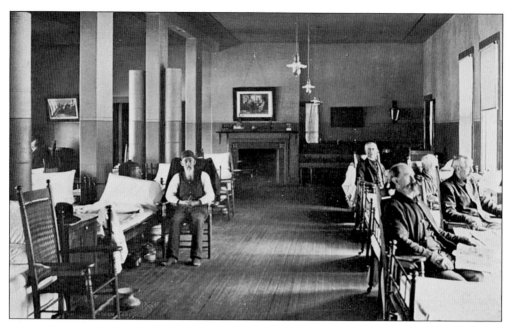

This ward in the new hospital was built in 1891. Air heated by steam was circulated continuously to maintain a constant temperature. A wash area with several faucets can be seen to the right of the fireplace in this *c*. 1895 photograph. (TL)

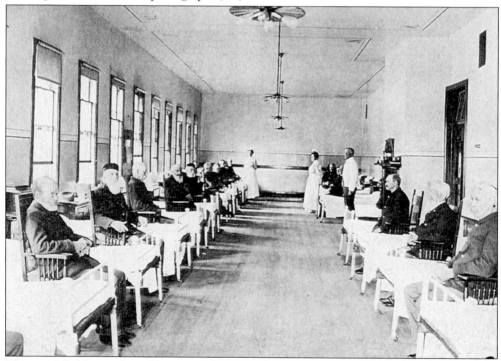

This sun-filled hospital ward has new white porcelain hospital beds about 1900. The National Board of Managers decided in 1899 that old barrack-style beds were no longer suitable for its aging members. The two female nurses were among the first group to be hired at Togus. The number of female nurses fluctuated between 8 and 22 during the first 20 years. (TL)

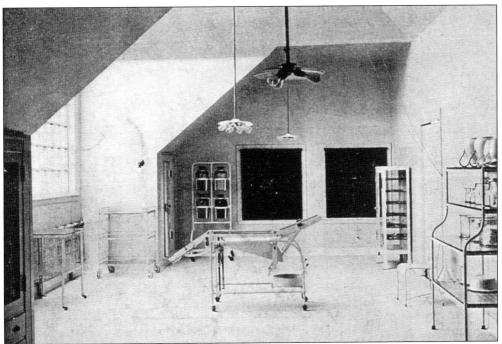

This 1904 photograph shows how natural lighting was used to provide as much light as possible for the new operating room. Powerful incandescent lights are shown over the portable modern operating table. The operating room was on the third floor of an addition to the main hospital administration building, at the center between its south and north wings. A white porcelain medicine cabinet holds operating instruments. (TL)

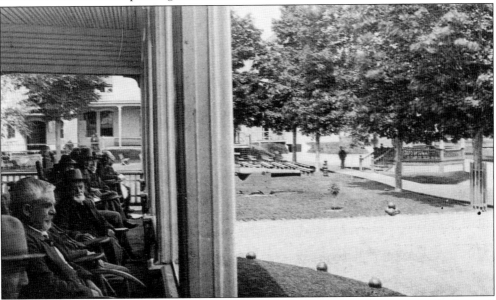

Convalescents in wheelchairs and porch rockers take in a summer afternoon on the hospital piazza about 1903. On the right, just beneath the trees, is the south bandstand where the home band played every afternoon except Mondays during the summer. For the year ending June 30, 1904, over 41,000 people visited Togus. (TL)

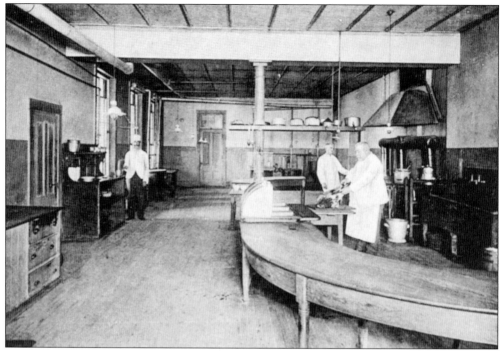

The hospital kitchen was in the large main hospital built in 1891. The kitchen staff consisted of a head cook and six assistants. There were two dining rooms for the convalescents where a sergeant and six men served the needs of 175 men in one dining room and 60 in the other. (TL)

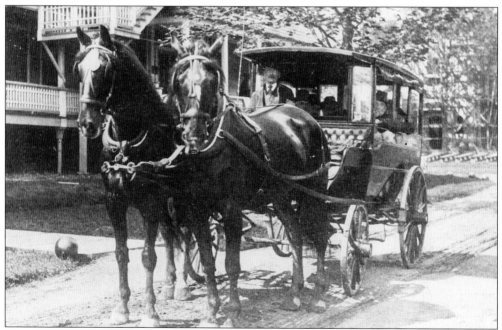

The Togus ambulance, about 1904, comfortably transported six or more sick veterans to the hospital. The ambulance was a gift from two aging veterans who saved a substantial amount of their pensions over the years. (TL)

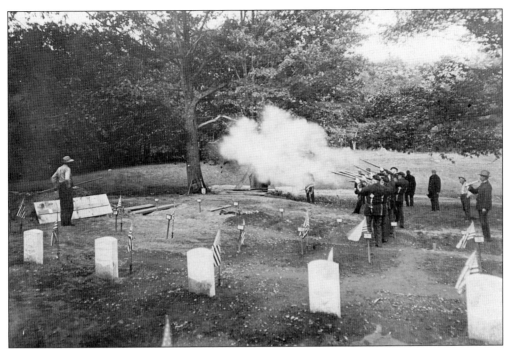

The Togus Firing Squad fires a salute at the burial of a veteran in 1894. Funeral arrangements at Togus included a detail of 40 men with six selected as pall bearers and the Togus Home Band. Each man was buried next to the last man to pass, regardless of race, religion, nationality, or creed. (TL)

Memorial Day marches head to the cemetery about 1904. The parade is marching past the Togus Electric Depot building and the barracks of Company F and Company G on the left. This road to the cemetery was discontinued and no trace of it is visible today. (TL)

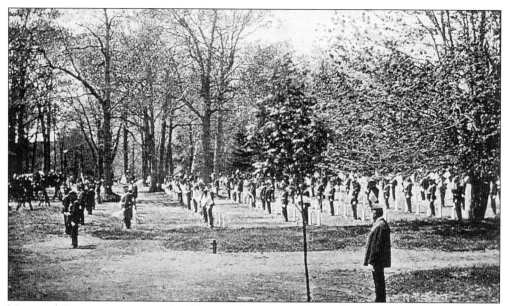

Memorial Day ceremonies were held here on June 17, Bunker Hill Day, from 1870 until 1901 by the Togus Post of the Grand Army of the Republic to avoid the sometimes cold May weather. The laying of wreaths and bouquets was done after the singing of the Decoration Hymn. In 1890 at the 23rd Annual Encampment of the GAR in Augusta, Maine, Luther Stephenson, governor of Togus, made the following remarks that follow. (TL)

"All is not gold that glitters! Comrades, I say to you, and send a message through you to those you represent, and it is this:

Only when the family circle is broken, when the companion of your life has passed to the better country, when your children are scattered and can no longer perform the offices of filial love and duty, when your hands refuse to work, when your feet move feebly, and your brain fails to respond to your bidding, when you are poor, sick, and weary, only then should you seek the National Home, and not with the expectation of finding a real home, but only a resting place near the end of your journey toward the home beyond."

"The broken soldier, kindly bade to stay,
Sat by the fire and talked the night away,
Wept o'er his wounds or, tales of sorrow done,
Shouldered his crutch and showed how fields are won."

—*History of Togus*

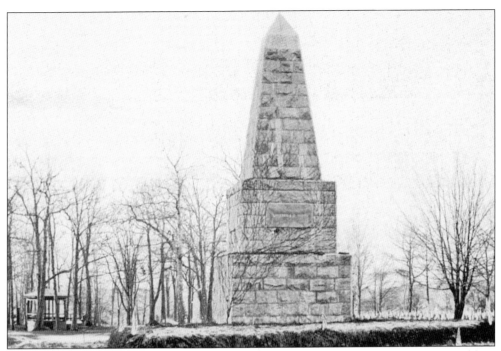

This large granite monument in the Togus cemetery was erected in 1886 to honor all soldiers and sailors who fought for the Union. To the left of this *c.* 1894 photograph is an octagonal bandstand for the home band that played at every funeral. (TL)

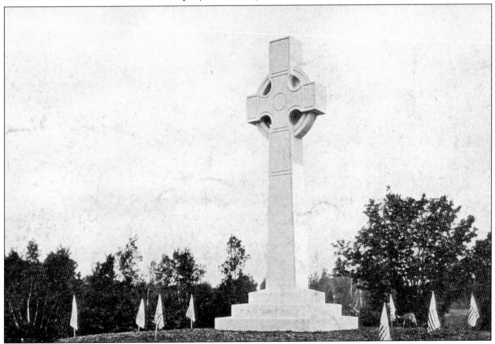

The "new" East Cemetery was opened in 1901 as a result of space limitations in the old cemetery. This cemetery was closed for several months in the early 1900s to drain a high-water table and institute a new sanitation system. (TL)

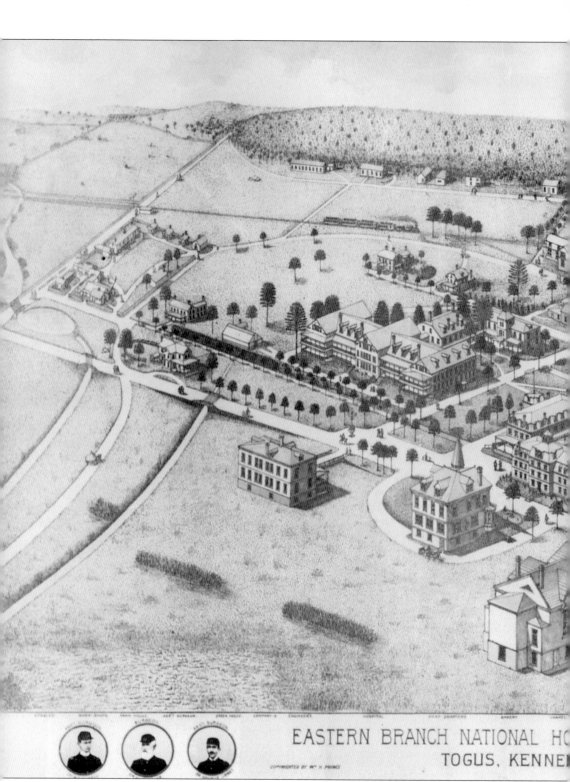

EASTERN BRANCH NATIONAL HO
TOGUS, KENNE

This 1891 bird's-eye view by William H. Prince highlights the new buildings added to the home in the 1880s. The veteran population did not reach its peak until June 1904 at 2,793. Year after

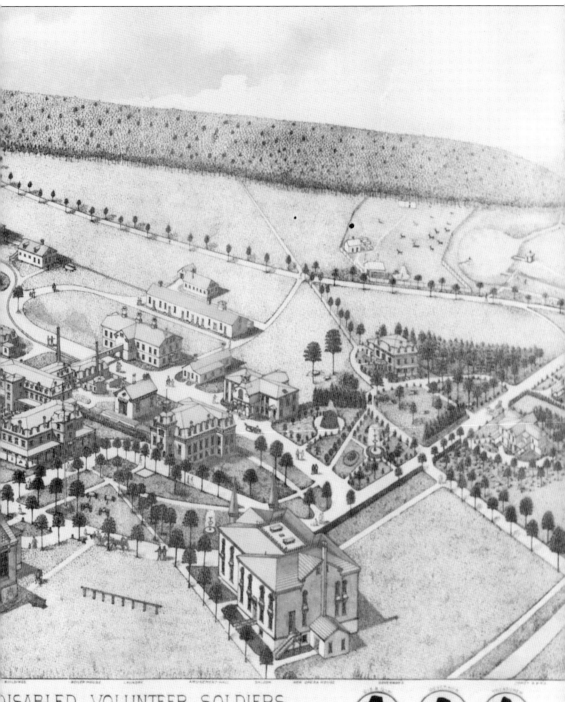

DISABLED VOLUNTEER SOLDIERS.
COUNTY, MAINE.

year, new buildings were added or improvements made to ease the last years for the aging Civil War warriors. (TL)

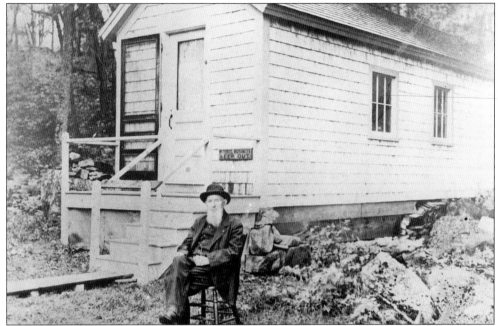

Togus resident Daniel A. Mullett of Newfane, Vermont, sits in front of his camp just off the grounds of the home about 1895. Some veterans built camps in the woods and received outdoor relief equal to the amount of money required to house a veteran at Togus. In this building with the sign, "Without Business Keep Out," Mullett conducted experiments. In letters home he claimed that he invented a "perpetual motion" machine that could run for a month to six weeks without stopping. He died about 1905. (TL)

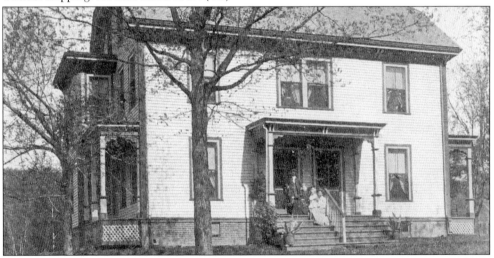

The bandmaster and chief engineer's quarters at Togus is shown here about 1903. This building was formerly the hotel that Horace Beals used to recuperate from illnesses before deciding to buy the property. It was moved to this location and renovated into a duplex for the new bandmaster (Prof. Berthold W. Thieme) and the chief engineer. The south side of the duplex was the bandmaster's. On the steps, listed from top to bottom, are Professor Thieme, Anna Thieme (his wife), a grandchild, and their daughter Marie. The Thiemes also had a son named Lewis. (TL)

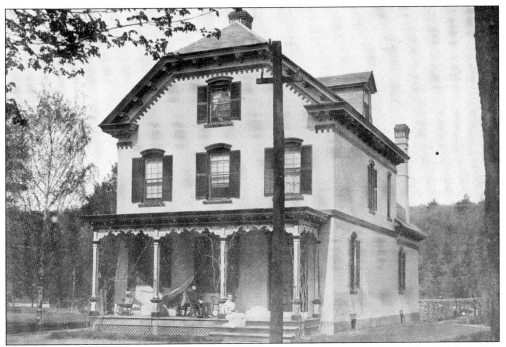

The chaplain's quarters is pictured here about 1904. This two-story brick building with a one-story ell in the rear was originally built in 1878 as the surgeon's residence. Facing southeast, the house was located several hundred feet southwest of the old shoe shop. In 1904 the house was occupied by Rev. H.S. Burrage and his family. (TL)

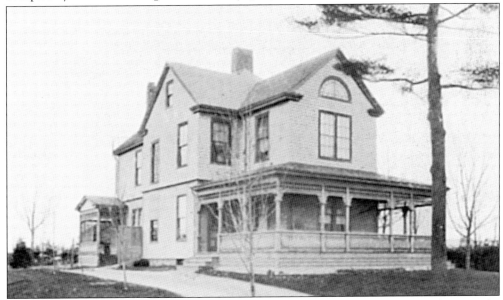

The assistant surgeon's residence, c. 1896, was on Rockland Avenue. This house became the home of Assistant Surgeon Dr. W.E. Elwell when it was completed in 1890. After Dr. Elwell was promoted to surgeon in 1897, he continued to live in these quarters. Togus had always been supportive of its disabled veterans, and at least one furthered his education and obtained a medical degree after leaving Togus. (TL)

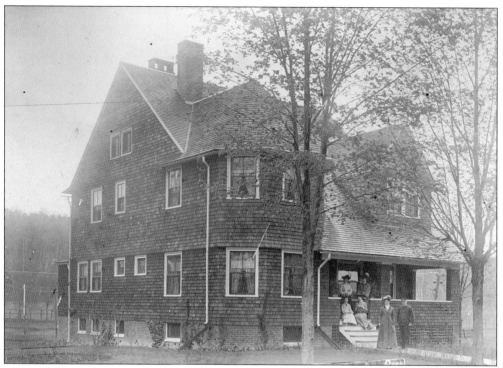

The quartermaster's residence was built in 1889 on Rockland Avenue, near the governor's residence. The back of the house looked out upon the deer park and the ridge beyond. This *c.* 1900 photograph appears to show the quartermaster, Capt. William H. Anderson, and his family on the porch. (TL)

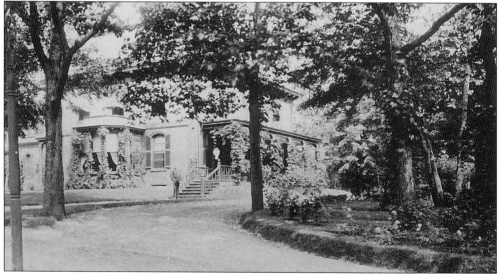

The governor's residence is pictured here *c.* 1893. In the 21 years since this house was built, there had been many changes in the landscape. The National Home had a grounds crew that planted shrubbery, flowers, vines, and trees, and tended to the lawns. Luther Stephenson, governor since late 1883, was living alone, like many of veterans who had come here to die. Mrs. Stephenson had succumbed to a stroke in 1886. (TLS)

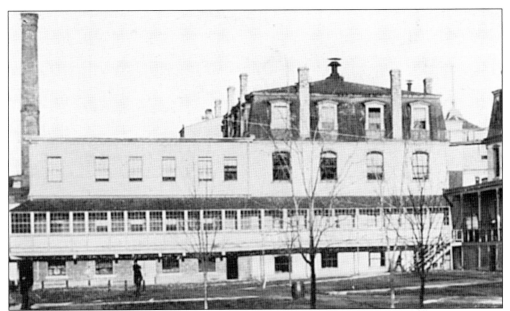

The left half of this 1895 photograph shows the two-story addition to the west wing of the main barrack built in 1875. This addition was criticized by the *Kennebec Journal* in the November 3, 1875 edition: "The roof of the new building is unlike those of the other buildings, which we think is an architectural blunder. . ." In 1888 removable glass windows were added to the porch. (TL)

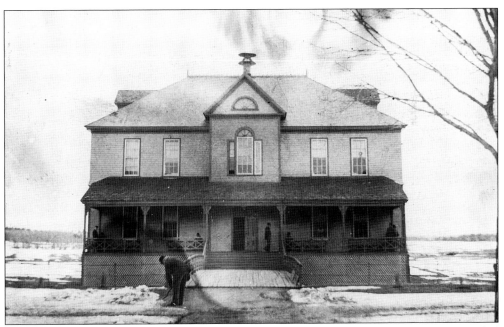

Barracks G was completed in 1885 on the east side of Rockland Avenue and immediately filled to capacity. In January of 1886 there were 1,326 veterans at Togus and a waiting list of 48. As the years passed, many of these old warriors and survivors of battles such as Gettysburg found it more difficult to manage on their own, as family and friends passed on, and applied for admission to a veterans home. This photograph was taken *c.* 1900. (TL)

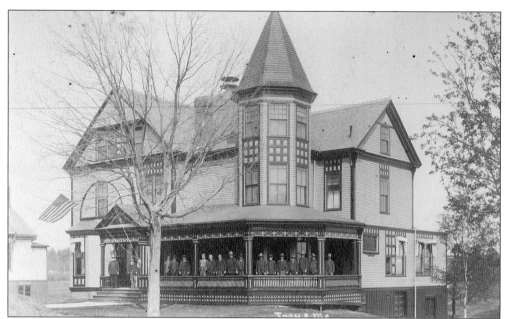

"Head Quarters," was the name of the Togus Administration Building constructed in 1889. This *c.* 1900 photograph shows Togus Gov. Samuel Allen on the extreme left under the portico. Allen's office was located in the left corner facing Rockland Avenue. A female civilian clerk on the second floor served as the governor's telegraph and telephone operator, as well as stenographer and typist. (TL)

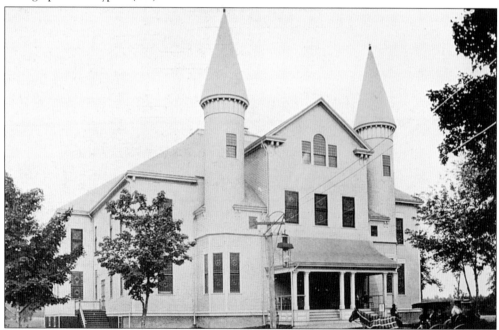

The opera house in this 1895 photograph was built in 1893 from a plan by Gardiner architect E.A. Lewis, who designed several buildings and residences at Togus. Electricity was routed from Augusta to Togus on October 30, 1888. Notice the new light attached to the telephone pole and the horse blanket. (TL)

The new chapel in this *c.* 1895 photograph was built in 1889 for $5,000 and contained a clock and bell from the Howard Clock Company of Boston. It was named Ward Memorial Chapel after an Englishman, who for unknown reasons bequeathed his entire fortune of $100,000 to the National Homes. (TL)

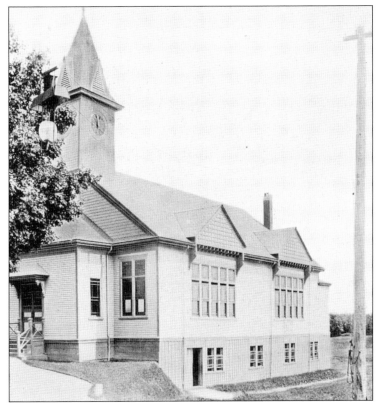

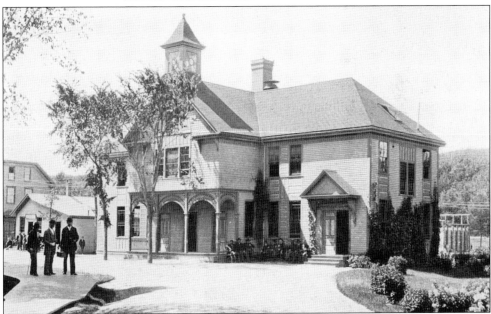

The beer hall in this *c.* 1895 photograph was constructed in 1890, although lager beer had been sold at Togus from the late 1870s. Drunkenness was a serious problem, and it was believed that keeping the residents home was preferable to them procuring stronger liquor off the premises. (TL)

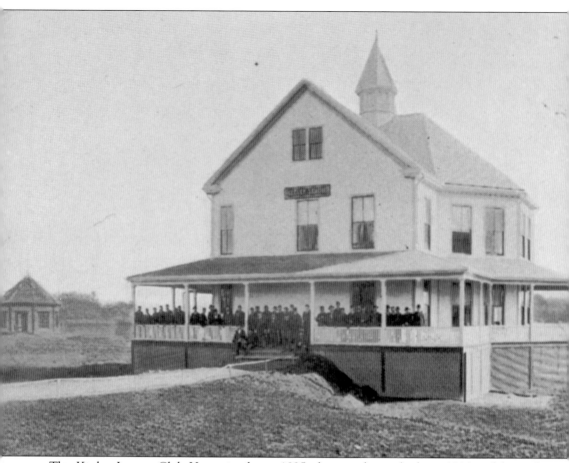

The Keeley League Club House in the *c.* 1895 photograph was built in 1894 and located between Ward Chapel and the opera house. The "Gold Cure Treatment" for intemperance was introduced at the National Home in 1892, but was not associated with the medical department of the various branches. A combination of patent medicine and rehabilitation practices it was the trend at the different branches for several years. The "Keeley Cure" evolved from the medical practice of Dr. Leslie E. Keeley of Illinois, who opened a sanitarium for alcohol and drug addicts using treatments he perfected, and he became famous and wealthy as a result of his cure. To his credit, other than the use of a patent medicine containing bichloride of gold, his methods were compatible with today's practices. He emphasized collective meetings with self-confession, encouragement, and helping each other, and keeping a distance from situations that could temper old behaviors. By November 1897, the Keeley "Club" was enlarged and opened to all members of Togus as the "Club House." It was not necessarily due to failure that it was disbanded. Many of the elderly veterans were having health problems and died. Discharges from the home for continued disrespect of rules and regulations also took a toll. (TL)

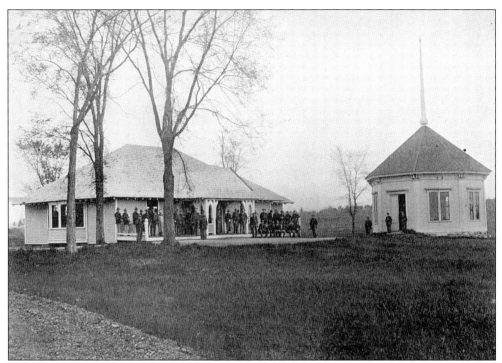

This *c.* 1903 photograph shows the new canteen and beer hall that had just been built. In 1905, the old beer hall was moved and remodeled into the new "Home Hotel." The canteen and beer hall were closed abruptly by the National Board of Managers in 1907, ending about 35 years of beer being available to the veterans of Togus. The buildings were demolished in 1925. (TL)

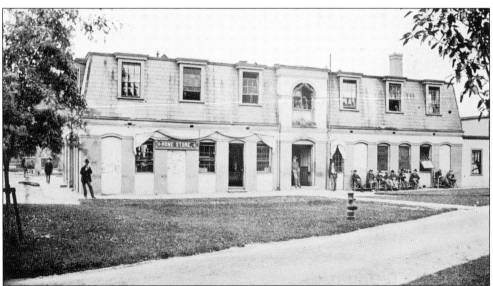

The Home Store and quartermaster's quarters, *c.* 1896, moved into the first floor of the building after the shoe shop closed in 1883. The store was open to visitors as well as residents and did $15,000 in sales in 1893. A portion of Company C was housed on the second floor when this photograph was taken about 1896. (TL)

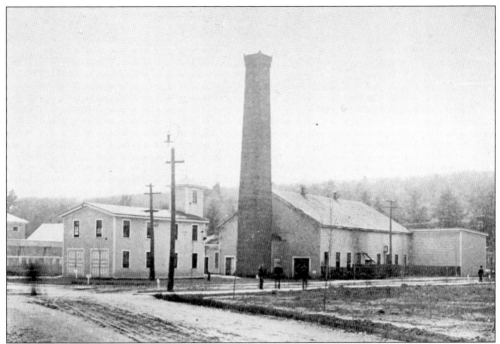

In the far right of this *c.* 1903 photograph is the 18-foot-tall coal shed, and in the center is the powerhouse and smoke stack. A typical mid-size town fire station built around 1890 is to the left of the smoke stack and consisted of two bays that held the ladder trucks and other fire fighting equipment. (TL)

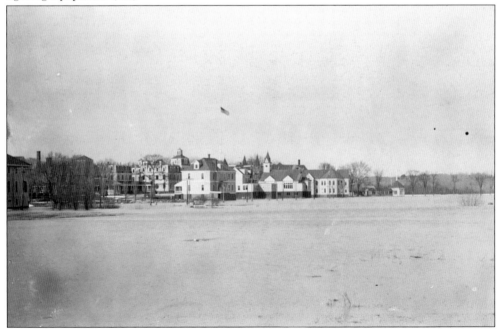

Much of the land to the east and south of Togus flooded during the spring time as shown here about 1913. The difficulty of drainage led to severe pollution problems by the early 1900s and led to the closing of the famous Togus Mineral Spring. (TL)

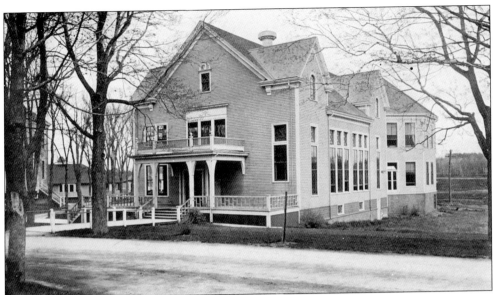

The front portion of the former Keeley League Clubhouse was demolished and a large addition was constructed in its place about 1900. The expanded clubhouse was occupied by pool and billiard rooms, a lodge room for the GAR, and a meeting area for Independent Order of the Good-Templars and Ladies Relief Corp. Chess, checkers, dominoes, cribbage, and other games were regularly played in other rooms. No form of gambling was allowed at Togus. This photograph was taken c. 1903. (TL)

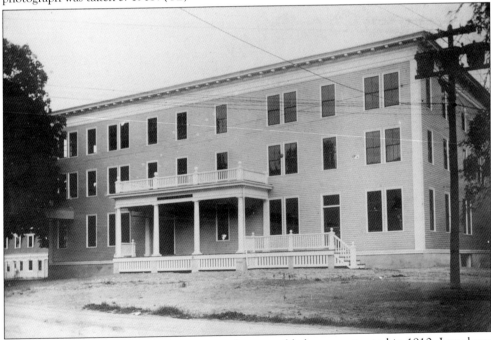

This new building was the commissary store house and bakery constructed in 1910. Just above the first-floor window at the far left can be seen the enclosed steam pipes from the powerhouse to heat the commissary and the third-floor female dormitory. The third floor consisted of the waitresses dormitory, sitting room, toilet, and bathroom. (TL)

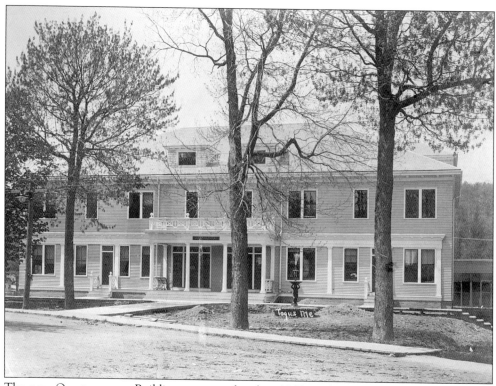

The new Quartermaster Building was completed in 1903, with a fountain on the front lawn similar to the one at Battery Square. The first floor contained the quartermaster offices and a room where clothing and uniforms were issued. A dormitory for the quartermaster clerks was located on the second floor, while supplies were stored in the basement. (TL)

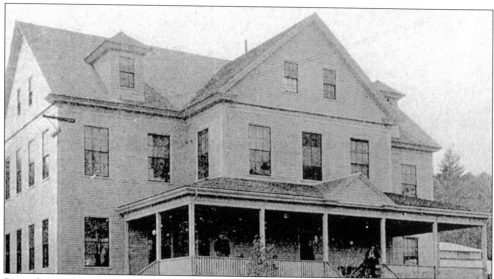

Barrack F with eight wards was completed in 1902 at a cost of $30,000. The rear of this building had a wing the same size as the front, with the same three-sided piazza. In the right rear of this c. 1904 photograph is a summer barrack. (TL)

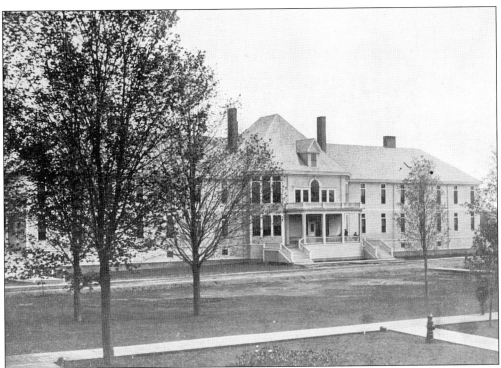

The Company E and H Barracks is pictured here about 1904. Barracks were organized in accord with the basic infantry unit of a company, and were made up of approximately one hundred men. This double barracks, built in 1902–1903, was designed for 228 men, divided into eight wards with four latrines and bathrooms. Two wings extended from a central octagonal entrance, and a rear boiler room heated the building. (TL)

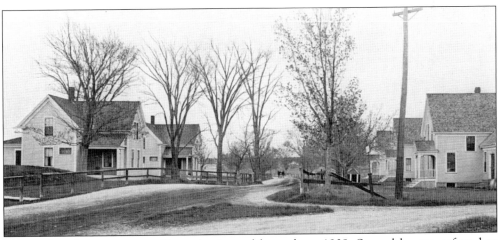

The civilian housing area at Togus is pictured here about 1908. Several houses, referred to as cottages, were built between 1899 and 1902 and rented to civilian employees. They were located on the Hallowell Road leading to the east gate at Chelsea. (TL)

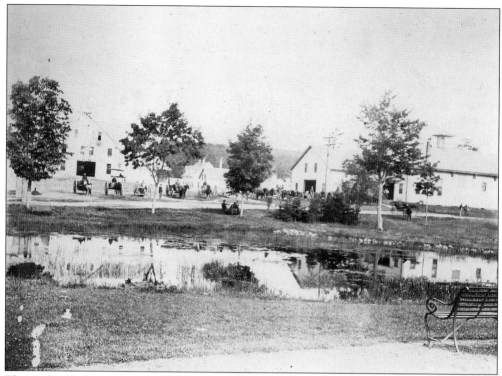

This is the Togus stable area as it appeared about 1896. Attractive benches for relaxing were located by the pond and in the right background is the stable for the officers' horses. The home's work horse stable is directly behind the wagons on the left. All the equipment was kept clean and well cared for by a foreman and three veterans. (TL)

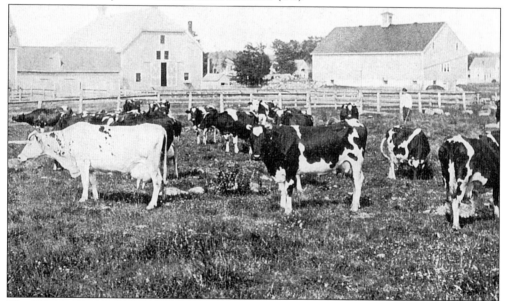

The Togus Dairy Farm was photographed here near the south gate about 1900. The large barn in the center, built in 1893, housed 5- Holstein cows and 12 calves. The hay barn is on the right. (TL)

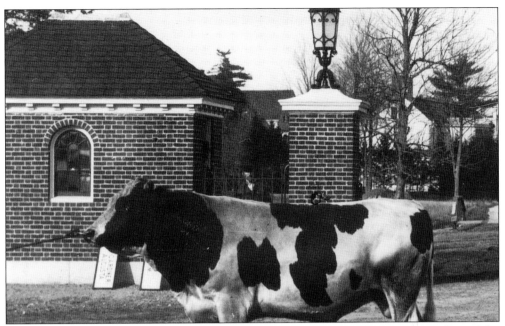

According to legend this bull killed a man at Togus. Perhaps the bull was a descendent of the great bull, Zaandam, who was a 2,000-pound five-year-old blue ribbon winner at the Maine State Fair in Lewiston in September 1880. Whenever he smelled a horse, a rage to gore and kill horses overtook him. One month after winning the blue ribbon, Zaandam was taken to the slaughter house in Augusta. (MHPC)

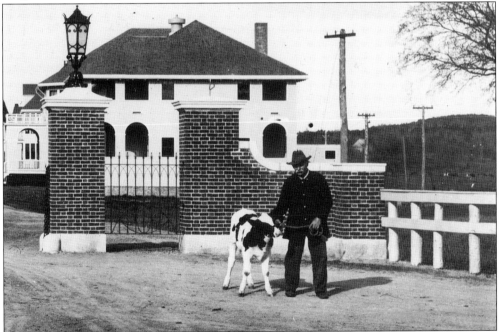

A veteran shows a Holstein heifer for a photographer at the south gate about 1910. Barrack B and O constructed in 1903 are in the background. It appears that the wires for the lights on either side of the gate are underground. (MHPC)

Togus was photographed here from the south gate about 1903. On the extreme left, just past Greely Pond Brook, is the west gate. The first building on the right of the west gate is the officers' stable, with the "County Road" going to the north. The road in the center, running right to left, is Hallowell Road, with Rockland Avenue heading north on the right side of this photograph. (TL)

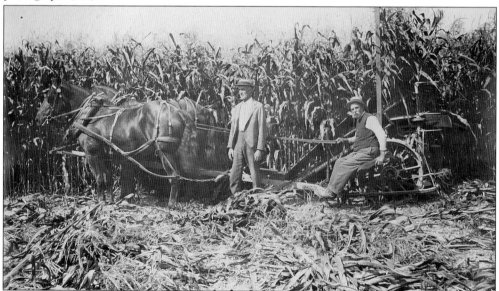

On September 18, 1907, James E. Libby (standing) was photographed while checking the progress of the 8-to-10-foot cornstalks. The man seated has his hands on the reins of a two-horse team McCormick Harvester. At the turn of the century corn-canning operations operated in many parts of the state. (TL)

54

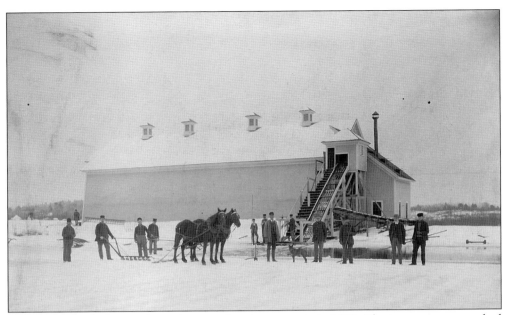

Eighteen-inch-thick ice is being harvested at the reservoir in 1906. The ice was cut or marked lengthwise, and then cut into blocks and pushed with long poles toward the icehouse. The blocks were placed onto an escalator to be lifted into the icehouse and stacked with sawdust for insulation. The tall man is front of the horses is James E. Libby. (TL)

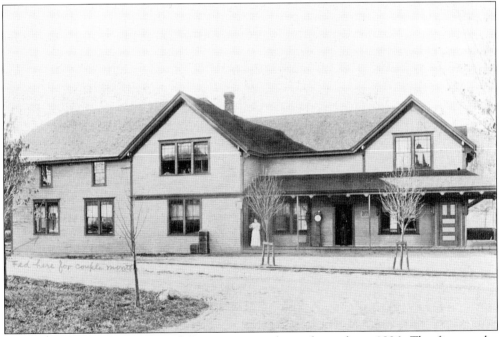

The Togus Railroad Station and Restaurant are shown here about 1896. The first regular passenger train arrived at Togus station on July 23, 1890, at 7:30 a.m. The restaurant, which catered to excursion travelers, was located in the left wing, while the Togus Home Band was housed on the second floor. The railroad track in the foreground led to the Togus coal shed. (TL)

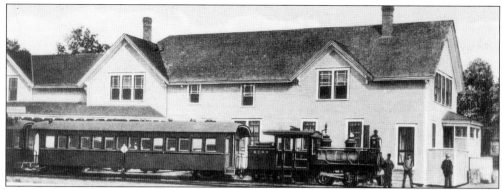

The narrow-gauge train's engineer and fireman, alongside a Togus veteran, stand ready about 1900 to board Locomotive No. 2, which was built in Portland in 1891 and named the *Veteran*. The seats of the passenger cars were installed facing inward on both sides. There were several "two footer" railroads like this one that served Maine by the early 1900s. (ORC)

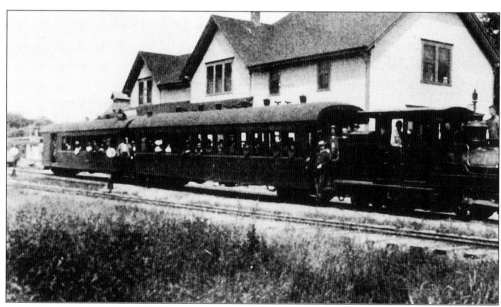

Veterans are pictured here departing Togus Depot on Locomotive No. 2 for the Randolph Depot about 1899. The first rail car was for passengers while the second carried passengers and baggage. The distance between the rails was 2 feet and consequently the trains were called "two footers." (RM)

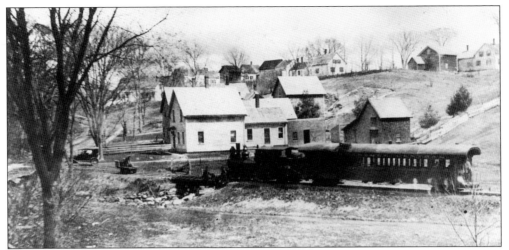

The Kennebec Central Railroad Locomotive No. 3, with an odd roofed coach, is headed to Randolph about 1918. The train was approaching a trestle on Togus Stream near Winsor Street in Randolph. To the left of the locomotive is an old hand car used to check the rails and rail bed. The automobile is a Model T Ford built after 1915. (RM)

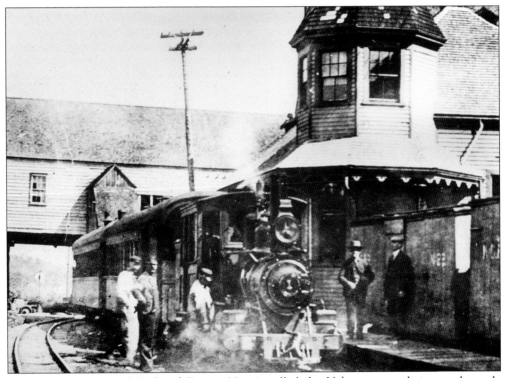

The Kennebec Central Railroad Engine No. 1, called the *Volunteer*, was being made ready for a trip to Togus about 1895. The Randolph Depot is to the right of the train, while the old brick building out-of-view housed Goggin's IGA for 50 years. The upper-background shows the Randolph side of the wooden Gardiner-Randolph bridge, destroyed by flooding in 1896. (JEL)

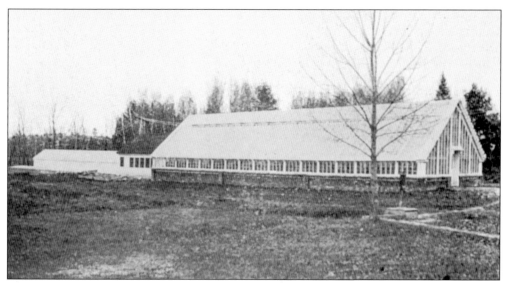

The original Togus Greenhouse was constructed in 1887 and was located to the north of the amusement hall. The area nearby was later used for the Electric Railway Station, constructed in 1900. The greenhouse was used to grow flowers and plants that provided a park like atmosphere to the homes' grounds and pleased the residents during the long winter months of semi-isolation. The greenhouse was torn down about 1903–1904. (TL)

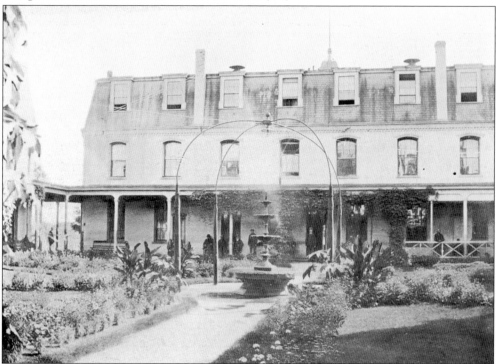

The interior courtyard of the barracks quadrangle, about 1895, had a beautiful multi-tier fountain and a variety of plants and flowers. The courtyard provided a very pleasant area for the less physically active members at Togus. An arch, with a high-wattage incandescent light, was placed in the center of the courtyard in 1890. (TL)

The Battery Square fountain is pictured here about 1895. The National Home Board of Managers signed a 20-year contract with the Augusta Water Company in 1887 to supply water to every building and six ornamental fountains. Unlimited water cost $200 per month the first year and increased to $455 per month at the end of four years. (TL)

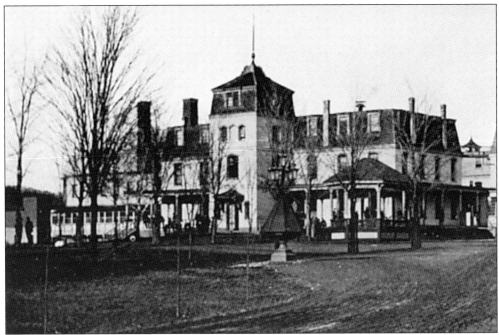

Newly planted trees and an interesting incandescent light fixture with five separate lights, which provided ample lighting near the new bandstand, are shown here about 1895. Early spring or mud season is apparent from the road condition, while several veterans appear on the piazza of the south facing main barracks for some late afternoon warmth. (TL)

59

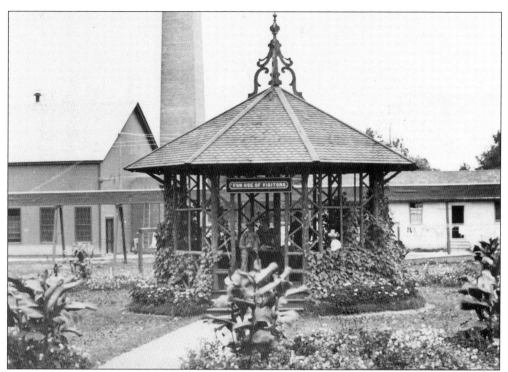

A wonderful rustic-style pavilion was surrounded by beautiful plants and flowers about 1895. The sign reads "For Use of Visitors," for it was an area to rest and converse while touring the grounds and buildings of Togus. The pavilion was located about 200 yards from the railroad depot and next to the laundry on the right side. It was constructed about 1892. (MHPC)

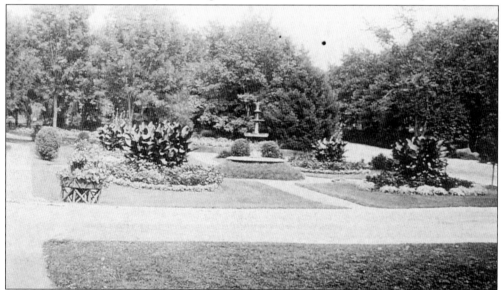

Rockland Avenue was photographed here looking north about 1893 from Battery Square. For several years John Burr, a well-known landscape gardener from Freeport, Maine, was responsible for ornamental planting at Togus. The road and walkways were smoothed, cut, and widened in 1888, with new plantings and fountains added. (TLS)

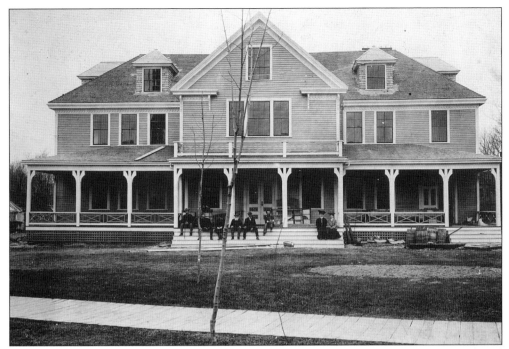

The new Home Hotel, previously the old beer hall, was photographed here after being moved about 200 feet north and extensively remodeled in 1904–1905. Piazzas were added to each side of the entrance and two dormers were built on the third floor. A large addition was also added on the back side. (TL)

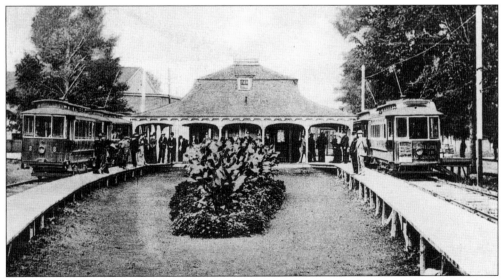

Visitors to the National Home at Togus are standing on the back platforms of the depot about 1903. Several car conductors are standing behind the tall bronze leaf South American Canna. At the left are cars number three in front and number six at the rear. To the right are cars number 18 and 17. (MHS)

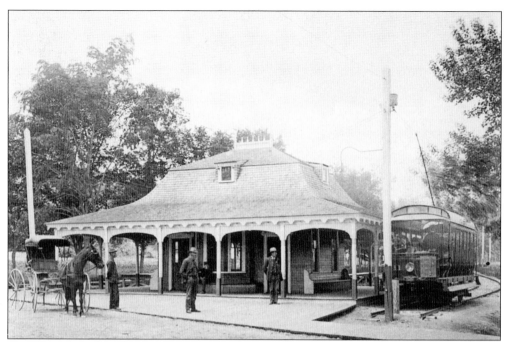

A Togus veteran by the horse and buggy appears to be waiting for a passenger about 1903. The Electric Railway Depot at Togus was built in 1900 and in the early 1900s a railway car was arriving or departing from both sides of the depot every 20 minutes in the summer. (TL)

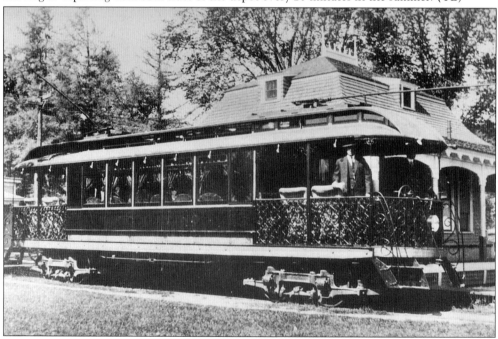

The electric railway parlor car *Merrymeeting*, c. 1910, was available for private rental excursions, with Togus being a popular destination. The *Merrymeeting* was very elaborate, with fancy iron grillwork and plush chairs in the enclosed areas and on the front and rear open platforms. (MHS)

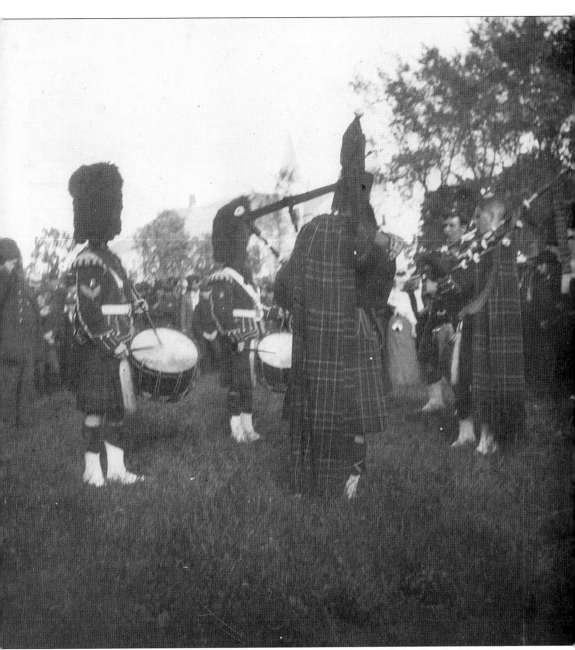

With the twin shires of the opera house in the background, a Scots Bagpipe Band of the Knights Templar from Montreal performed in a field near Governor Allen's residence. The Richard Couir de Lion Preceplary, a Montreal Masonic organization, was in the Augusta area for a convention with local Masonic bodies. A reception was held at Togus on August 16, 1901, with an estimated five thousand visitors attending. The visiting Knight Templars formed on Cemetery Road and marched past the Togus veterans along Rockland Avenue. The home band, situated across from the reviewing stand, provided music and a concert following the parade. A tour of the facilities were offered to the visitors. (BB)

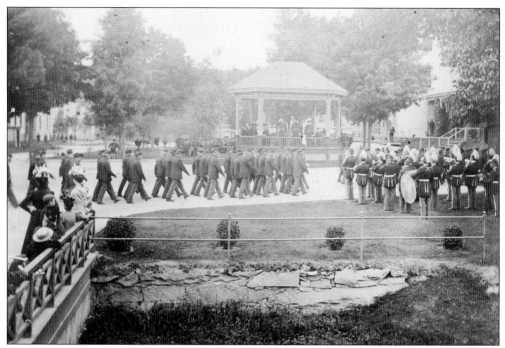

The veterans may have been returning here from the Memorial Day celebrations at the cemetery about 1899. The home band plays and officers on the bandstand salute the veterans as they march in quick step before dismissal near the south bandstand. Several fashionably dressed females appear at the left side of this photograph. (George A. Paige Photograph, TL)

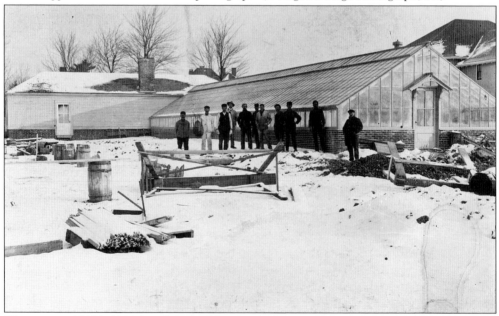

The winter of 1903–1904 found the builders finishing one of two greenhouses, which measured 22 by 92 feet. The greenhouse building contained a small sleeping room, office, and work area. To the right of the greenhouse is one of the barracks on Rockland Avenue. The propagating building directly behind this building measured 8 by 63 feet. (MHPC)

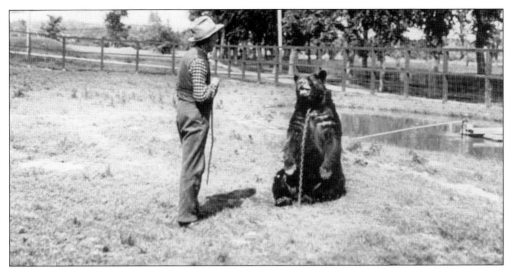

The deer park manager, Orice Oakes, guides a Maine black bear in a performance about 1908. In May of 1886, Togus officials purchased two young bears in Old Town, Maine. The Togus environment was not conducive to the health of bears, and the death rate at the park was quite high. (TL)

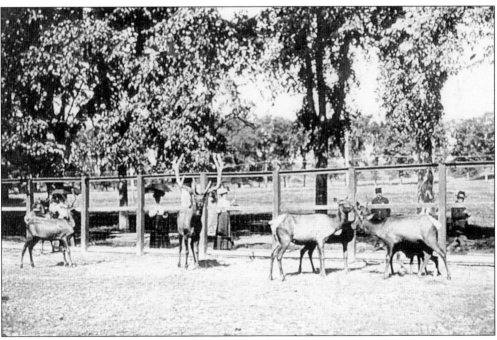

Visitors and residents admire several elk at the Togus Deer Park about 1905. The elk were brought from Minnesota in 1900, the same year Togus Gov. Samuel Allen's grandson donated several guinea pigs and rabbits to the park. (TL)

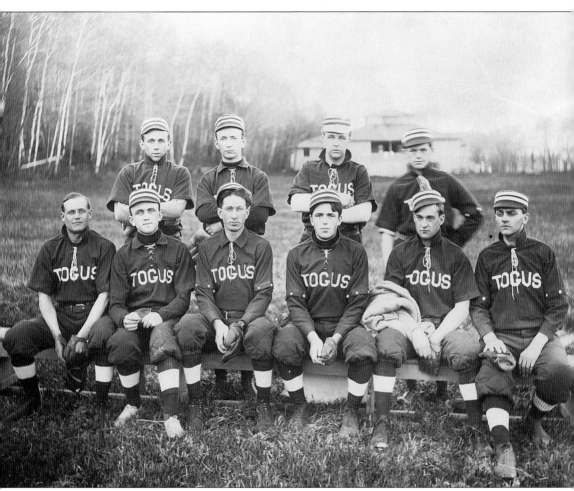

This may be a late April or early May practice session, for the second ballplayer from the right has one arm in a sweater, indicating he was keeping his arm warm for pitching. The small gloves, uniforms, and hats help date this photograph about 1901. The summer barrack, built in 1895, is in the background. (TL)

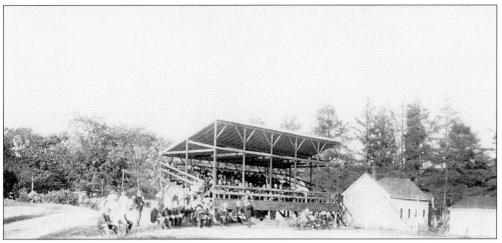

The grandstand was constructed in 1909 and seated 175 spectators. This field was used for baseball as well as other events. In 1912, $150 was allocated for baseball, which was very popular with the veterans and visitors. (TL)

An early Togus baseball team is shown here about 1915. The Togus teams were playing 35 to 40 baseball games a year from about 1910 to 1917 against area town teams and teams supported by local businesses. (TL)

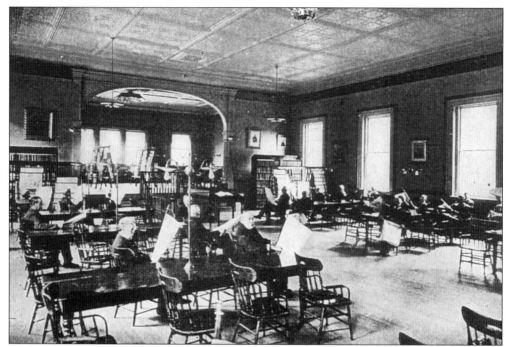

The library's reading room about 1907, after renovations to the amusement hall in 1905, allowed a capacity of over ten thousand volumes. Daily, weekly, and foreign newspapers and magazines were received to keep the members connected to their former residences. (TL)

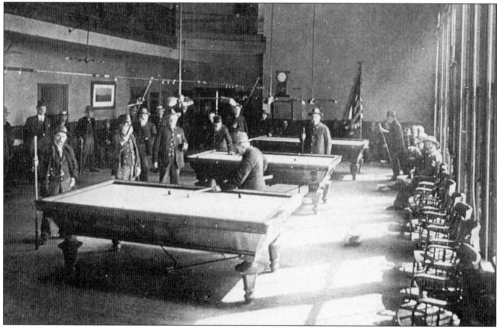

Three billiard tables were in use at the clubhouse, located next to headquarters in the old Keely League Building, in this c. 1910 photograph. These veterans were able to use the tables throughout the day. Rowdiness was minimal as a Togus guard was stationed in the billiard hall at all times. Several members owned their billiard cue sticks. (TL)

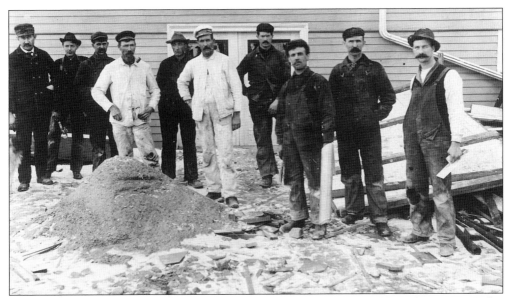

One of the Togus construction crews stands next to an unidentified building about 1903. A dog is visible in the far left of the photograph. As time took its toll on the veterans, civilians were employed at jobs that were previously performed by the residents of Togus. For the year ending June 30, 1904, the payroll for the 83-civilian employees performing various jobs was $20,940. (MHPC)

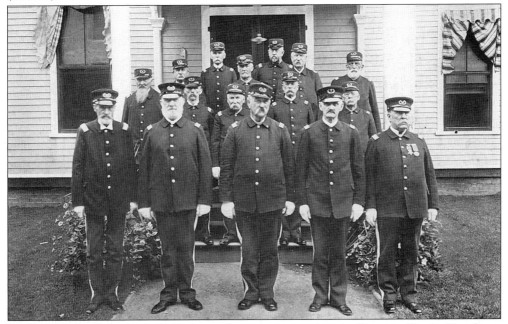

A photograph taken about 1910 shows the non-commissioned officers at Togus. Listed are, from left to right, as follows: (front row) Lt. J.L. Rea, Sgt. Major, Lt. G.J. Jeffery, QM Sgt., Lt. Charles McCulloch, Guard Sgt., G.F. Glidden, and Lt. G.W. Towle; (second row) Capt. Henry Negravel, Capt. C.B. Chollar, Capt. Daniel McAdams, Capt. G.A.L. Snoe, and Capt. W.S. Oakman; (third row) Capt. James Hickey, Capt. G.W. Belcher, Capt. Merrill Moore, and Capt. G.J. Page; (back row) Capt. W.W. Savage and Capt. B.F. Stoddard. (TL)

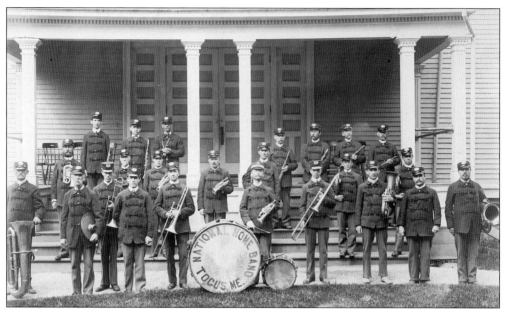

Twenty-four members of the National Home Band, Togus, Maine, are pictured here about 1910. The majority of the band members were civilians as most veterans were not able to meet the physical demands needed as infirmities took its toll on the aging veterans. (S.L. Newcomb Photograph, TL)

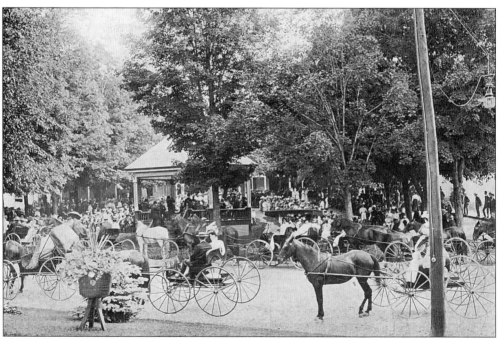

The north bandstand, about 1904, where a pleasant summer afternoon band concert has attracted an overflow crowd of veterans and visitors. (TL)

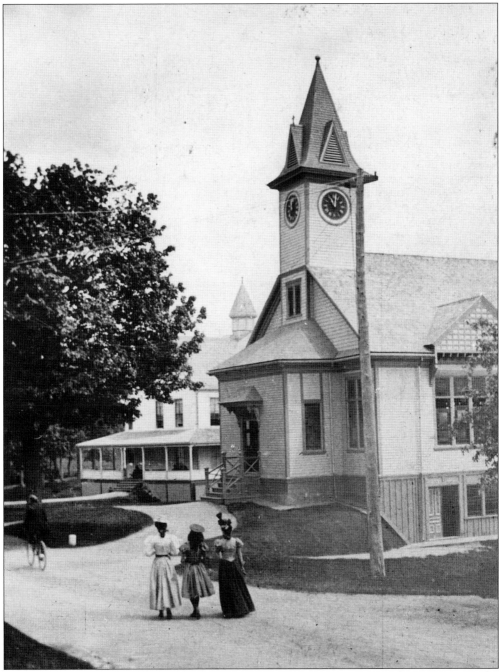

These three ladies may be headed for the chapel, or perhaps on a stroll, about 1898. Regular Sunday services were held at 10:30 a.m. Catholic services were held Sunday afternoons for a number of years. The building in the background is the clubhouse. (MHPC)

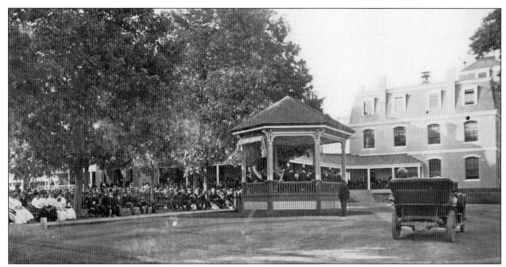

The Togus Home Band performs about 1913 for a large crowd. The band developed an excellent reputation over a wide area for providing a variety of excellent music. To the right of the bandstand is an early automobile with the license plate number 19084. (TL)

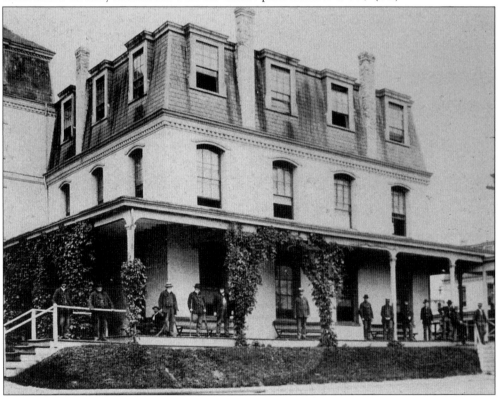

The southwest-facing main building and the veterans, themselves, were beginning to show some age in this 1893 photograph. In 1884, 96 veterans, out of an average of 1,098 residents of Togus, had lost a limb. About this time Togus was being referred to affectionately as the "Old Soldiers Home." The climbing vines may be wisteria, which grows quite rapidly and is a hardy vine in Maine. (TLS)

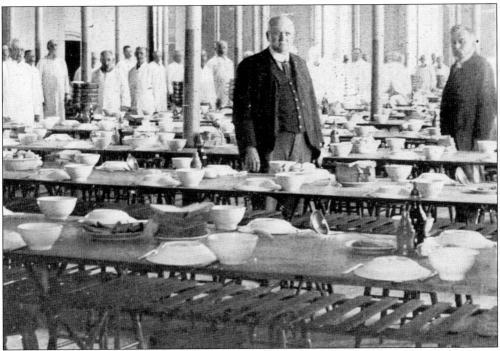

The general dining room, about 1905, had a seating capacity of 1,272. Under the tables a shelf was used to keep personal effects while dining and the use of stools ensured the old soldiers did not linger. Breakfast was typically at 6:00 a.m. and 6:45 a.m., depending on sunrise. Dinner was at 12:00 noon and 12:45 p.m., while supper was at 5:15 p.m. and 6:00 p.m. (TL)

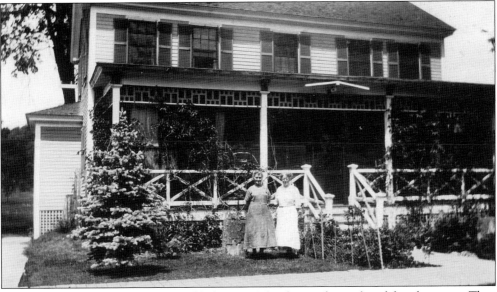

The old White homestead was remolded in 1900 for the newly employed female nurses. They were immediately successful with the patients and the Togus Administration. A shortage of veterans and other males available to become nurses allowed females trained in nursing to work at Togus. The woman on the right is Jessie Edith Ellis, the grandmother of Marjorie Brown of Litchfield. (MB)

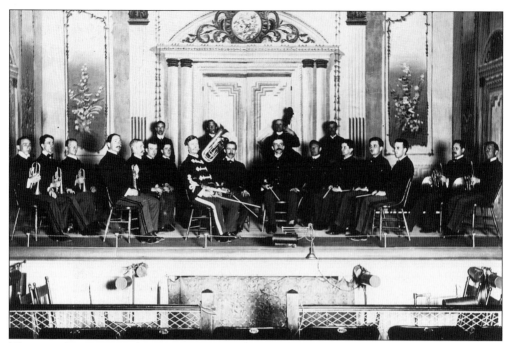

The opera house stage, about 1910, was one of the finest in New England. Professor Thieme is third from the left with a violin on his lap. There were many stage sets for use in different scenes built by the firm of Couch and Graham of Boston. The theater was managed by W.S. Quigley, with the profits used for the benefit of the veterans. (MHPC)

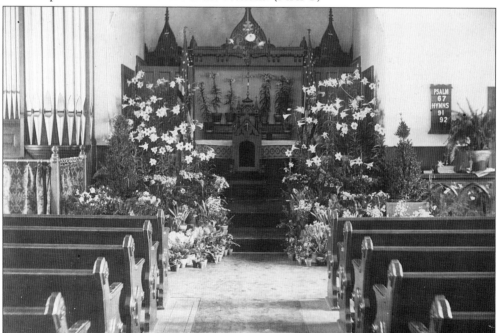

The interior of the Togus Chapel was probably decorated for an Easter service in this c. 1915 photograph. The chapel seated four hundred and featured a large organ, partially visible to the left of the alter. (TL)

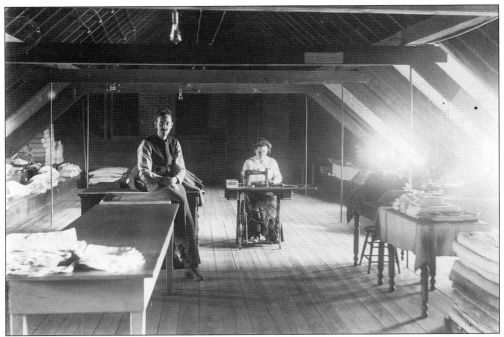

This appears to be the attic of the laundry about 1908. The woman at the sewing machine may be a civilian seamstress working at repairing uniforms and other salvageable items of bedding. The lower right corner has a dozen stacked mattresses. (TL)

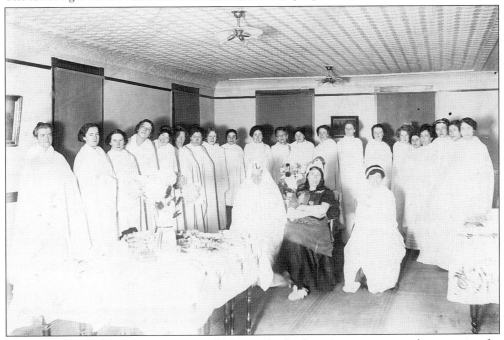

These unidentified ladies, in a room with drawn shades for privacy, appear to be preparing for an initiation rite about 1913. Many of the women are covered with blankets and were wearing head bands. The room may be the sitting room in the female dormitory that opened in 1908. Most, if not all, of the women were employed as waitresses in the several dining halls. (TL)

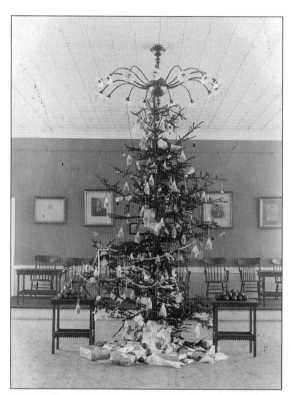

A Christmas tree sits in the meeting room of the GAR at the Togus Club House about 1914. Bagged candy hangs from the tree and gifts wrapped in plain paper sit under it, along with a large number of apples, which were popular treats at Christmas. (TL)

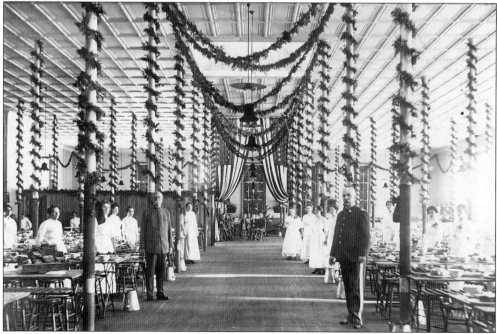

The home band is prepared for a meal time performance in the rear of the mess hall during Christmas season of 1913–14. Women were employed in greater numbers by the early 1900s, as the aging veterans found it more difficult to continue their duties. With the food on the table and milk cans on the floor, the evening's repast is at hand. (TL)

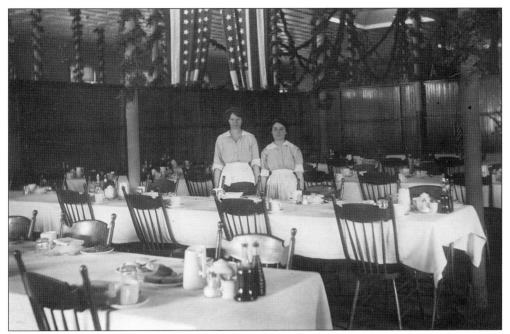

These two waitresses, about 1917, are in an enclosed dining room, separate from the general mess hall. The chairs indicate this dining area was used by non-commission officers and clerks. (TL)

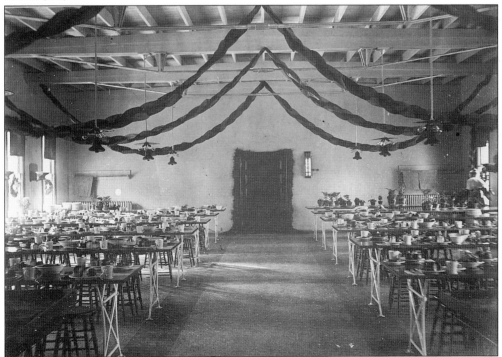

The hospital dining hall, about 1917, had a capacity of 196 in one seating and 369 patients were served at two sittings. There were no dining accommodations at this date for aged and infirm members. (TL)

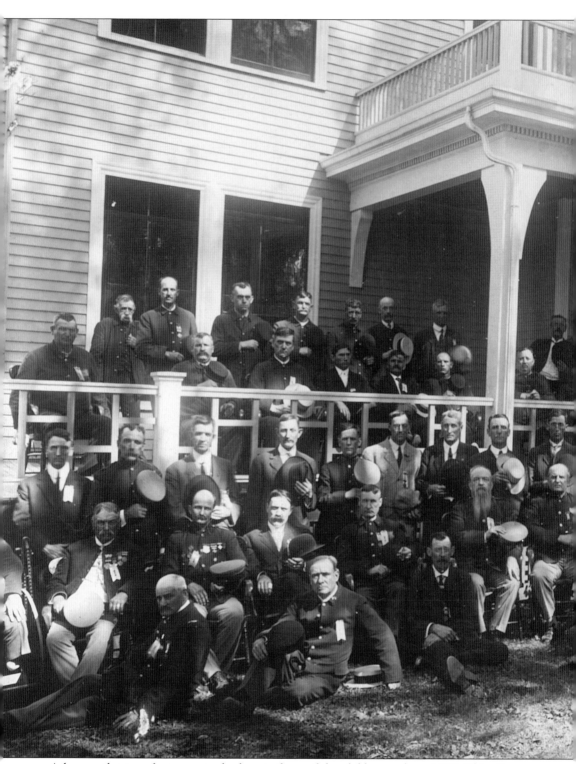

A large gathering of veterans took place in front of the clubhouse about 1917. This afternoon photograph of the young and old suggest a gathering in observation of Memorial Day events at

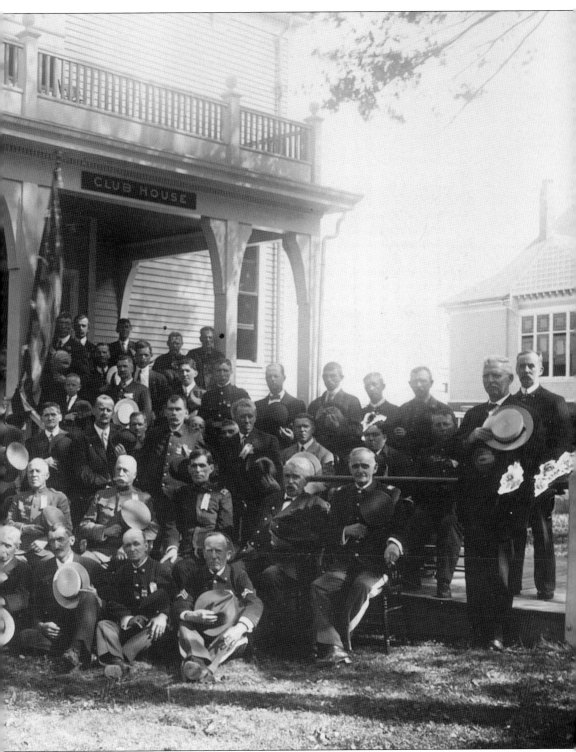

Togus to honor fellow comrades in armed conflict. (Edwin H. Washburne Photograph, TL)

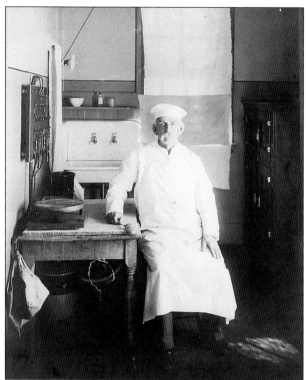

A pastry chef is at rest in his corner of the kitchen. Notice the large crocks under his cutting table, the marble slab on the chopping block, and the oak ice box with brass hardware in the right-hand corner. Compared to today's standards, the electrical circuit board and light by the sink look a little dangerous in this 1918 photograph. (TL)

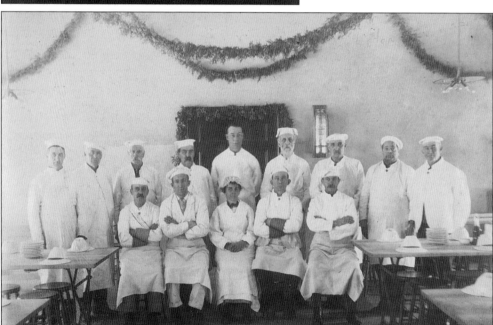

The kitchen staff is pictured in this group photograph. Sanitary conditions, as exemplified by the hats, had always been emphasized at all National Homes. During the Civil War, General Butler was a leading crusader for strict sanitary conditions for his troops whenever possible. His awareness of the connection between cleanliness and disease led to strict rules regarding conditions at the homes. (TL)

Three

The Veterans Home After the Great War

1919–1931

This veteran was known statewide as Count Von Bismark. His eccentricity made him a sought after member by visitors, and he was a crowd pleasing conversationalist. (TLS)

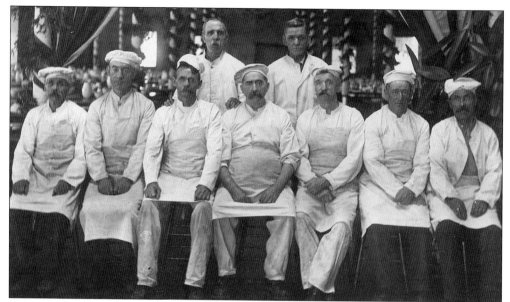

Cooks, bakers, and helpers from the main dining hall took time from food preparation to have their photograph taken about 1919. The main dining hall served 608 residents a day and used slightly more than 157,000 pounds of flour for bread, cakes, and pies in 1919. (TL)

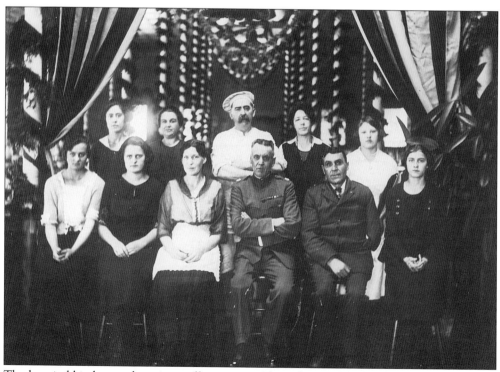

The hospital kitchen and service staff are pictured here during the Christmas season at Togus. The seated officer at the right in this c. 1919 photograph may have lost his left arm during World War I. (TL)

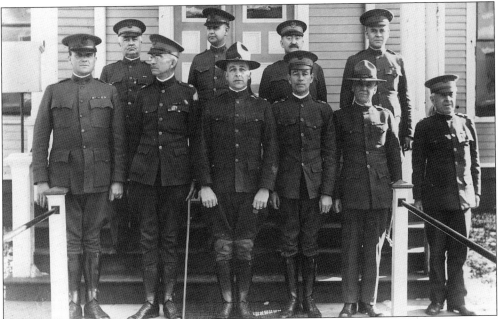

Here is a group of officers at Togus about 1920. Gov. William P. Hurley of Rockland is pictured to the far right in the front row. Niles L. Perkins, quartermaster and treasurer from Augusta, is the third from the right. The year 1920 was one of transition for the nation's veterans homes. Legislation was passed by Congress that separated the National Homes from other veteran services. (TL)

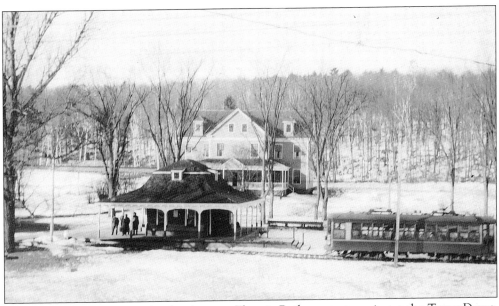

Several people are waiting for the Augusta Electric Railway car to arrive at the Togus Depot. In the rear of the depot is the barracks for Company F and Company G. This photograph was probably taken in the early 1920s from the second story of the Home Hotel. By this time automobiles were starting to supplant other means of transportation in visiting Togus. (GW)

Alfred and Florence Fuller of East Winthrop, about 1922, managed the Home Hotel for many years, known as "The Togus Gate Lodge" during their tenure. A magnificent bronze leafed South American Canna is in the background. (GW)

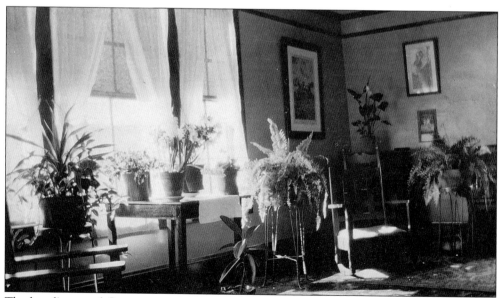

The hotel's second-floor sitting room is pictured here about 1924. The hotel kept plants and flowers year-round for the guests' enjoyment. The home's greenhouses were able to supply all the buildings at Togus with a large assortment of plants and flowers. Gen. John Marshall, a member of the National Board of Managers, was the first hotel guest. (GW)

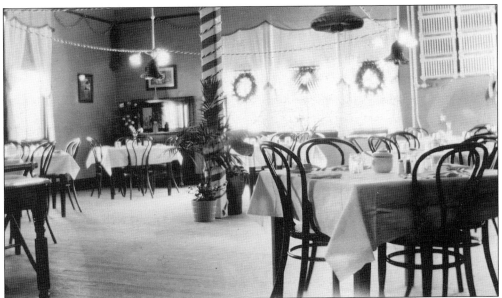

The main dining room of the hotel was decorated for the Christmas holiday season about 1924. There were eight tables with four chairs each in the main dining room. Sliding partitions could be moved to open the private dining room and combine it with the main dining room for large gatherings. (GW)

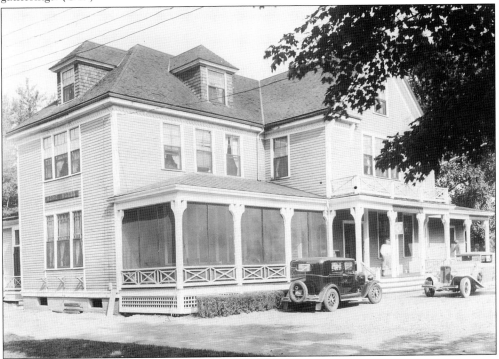

A very lovely automobile is parked in front of the Home Hotel entrance about 1930. The sign on the porch column by the entrance indicates a public telephone was available in the hotel. The veterans and their families appreciated the new 19-room hotel's accommodations and restaurant, along with the fine views while sitting on the porch rockers. (GW)

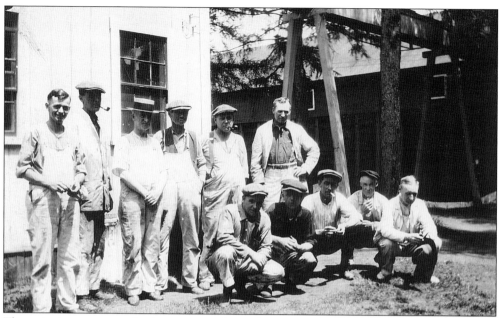

The painting crews at the home were always busy painting the exteriors and interiors of buildings. Several members of the crew are smoking pipes or cigarettes. In 1915, tobacco was issued free at the first of each month to veterans with no income. The veterans had a choice of one pound of chewing tobacco or 15 ounces of smoking tobacco. (MB)

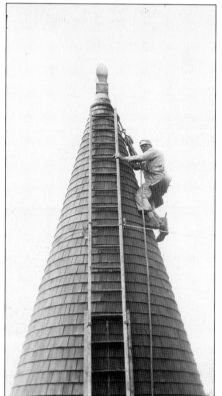

Steeplejack Harry Robinson appears ready to begin painting the top of one of the opera house's steeples in the 1920s. Seven tons of lead paint were originally used painting the opera house in 1893. In 1888, five painters escaped serious injury when a ladder they were all standing on collapsed as they were painting a cow barn. (MB)

Two painters from the painting crew are preparing to paint one of the steeples of the opera house in the 1920s. A ladder is placed flat on the front roof of the building while another ladder is leaning against the steeple. A crew member climbed to the top of the steeple and secured himself in a boson's chair while maneuvering around the steeple. (MB)

Snow covers the clubhouse ground in this 1920s photograph. By 1929, there were 457 Spanish-American War veterans, 541 from the Great War, and only 117 remaining from the Civil War. The overall total of 1,127 veterans at Togus was a dramatic decrease from a high of 2,793 in 1904. (GW)

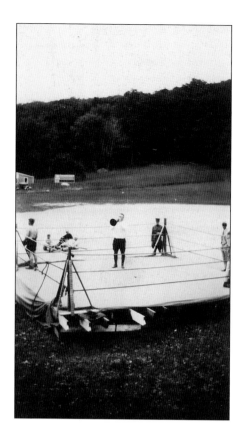

A boxing match is about to begin in a ring set up near home plate on the Togus baseball field. The announcer addresses the crowd in the bleachers while three baseball players rest on the dirt infield. (GW)

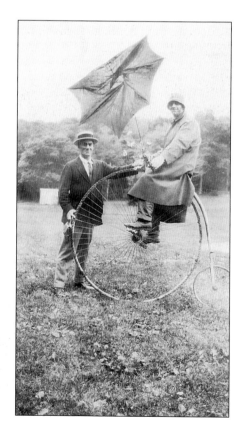

This old-fashioned high-wheel bicycle was possibly in a parade or other occasion for entertainment about 1925. The baseball field is in the background. (GW)

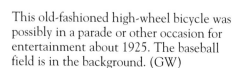

The home band is pictured in front of the opera house about 1926. Prof. Berthold W. Thieme, to the left of the drum, died on May 31, 1928, after only a few months of retirement. Before emigrating to America, Thieme had spent six years in the German Army and saw action in Austria and France. As a tribute to his leadership and dedication to Togus for over 45 years, he was allowed to be buried at Togus. (TL)

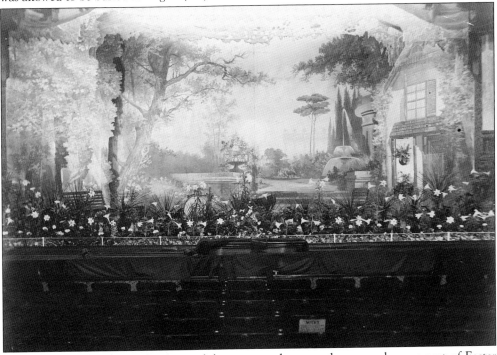

Fresh lilies and ferns line the front of the stage at the opera house, perhaps as part of Easter festivities in the mid-1920s. (TL)

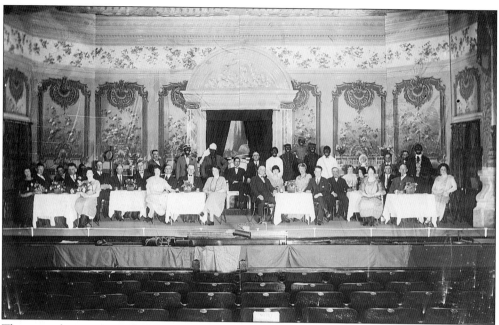

The opera house stage, about 1925, was filled with what appears to be members of a theater company, some of whom are wearing black face makeup. Togus was a regular stop for traveling entertainment groups appearing in New England. (TL)

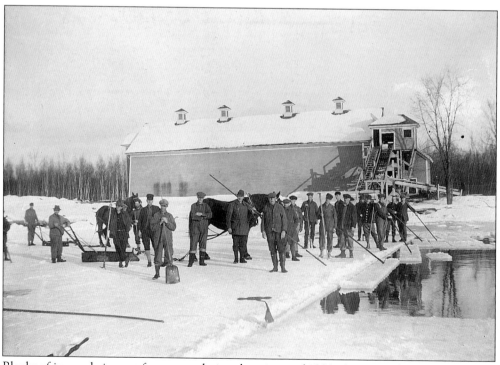

Blocks of ice are being cut for storage during the winter of 1924. A saw can be seen protruding from the ice in the foreground. Fifteen hundred tons of ice were harvested yearly for use at Togus. (TL)

This unidentified man was a highly regarded blacksmith at Togus for many years. The blacksmith shop was located about 100 feet behind the horse stables and remained an integral part of the community until automobiles became the leading mode of transportation. (KSB)

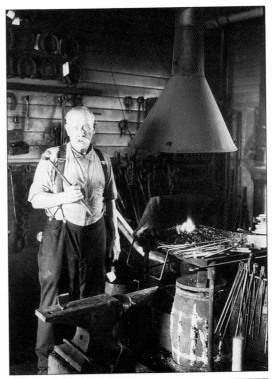

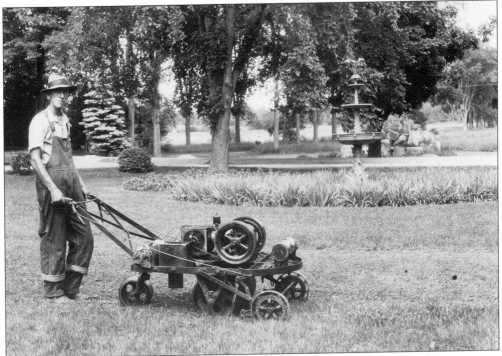

Audrey Spencer's father, Edmund Brown, is using the first gasoline-powered lawnmower at Togus about 1928. Brown is pictured in coveralls that were very popular with people who worked outdoors. (TL)

A pastoral scene was captured here looking toward the north entrance to Togus c. 1927. The photograph was taken on Rockland Avenue just beyond the quartermaster's residence and treasurer's home. To the extreme middle-left is the dam and outlet for the reservoir. The building to the right of the reservoir is the icehouse. (TL)

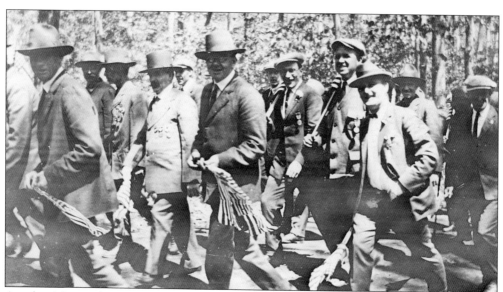

Another Memorial Day pictured in the early 1920s, but for a different generation of veterans. This photograph shows Spanish-American War and the World War I veterans. When the news of the armistice reached Togus in November 1918, Governor Hurley declared a holiday, and the home band played patriotic songs at the noon meal. (GW)

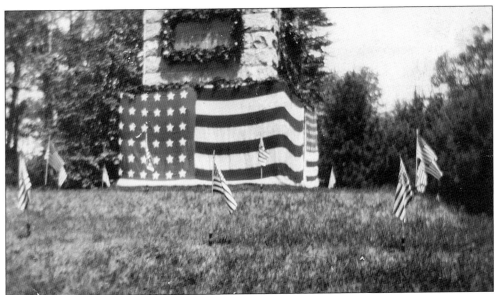

Three large flags surround the old granite monument at the cemetery on Memorial Day about 1920. During World War I a scarcity of wool meant veterans at the home had to be extra careful with their uniforms. Coal was in short supply and at least one large barrack and the Home Hotel were closed for the winter. (GW)

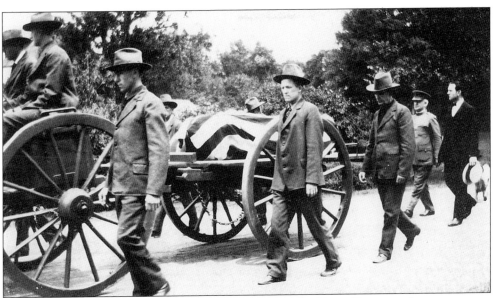

One more veteran is taken to his final resting place in the Togus Cemetery. In some years a funeral was nearly a daily occurrence. In 1919, 112 veterans died at an average age of 73. (GW)

"No vision of the morning's strife
The warrior's dream alarms;
No braying horn or screeching fife
At dawn shall call to arms."

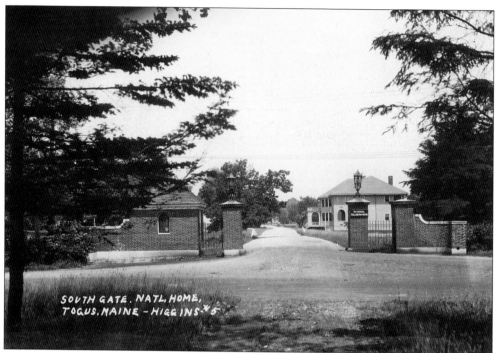

Togus seems to be almost deserted in this *c.* 1928 view from the south gate looking north on Rockland Avenue. The many changes in pensions and disability payments from legislative initiatives in 1920 accounts for part of the decrease in residents, but the great number of deaths of Civil War veterans was the main reason. (Lester Higgins Photograph, EM)

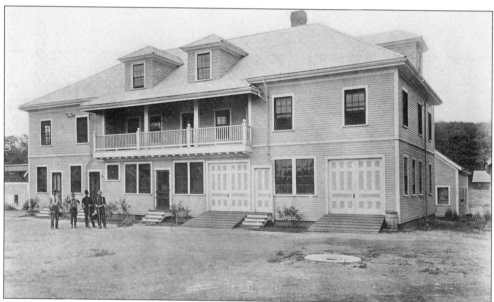

Four residents of Togus, about 1928, stand next to a farm building built in 1909. This building, similar in style to the quartermaster's building built in 1902, was situated behind the old farm building near the Hallowell Road. The second floor may have been used by civilian farmers working at Togus. The structure is still standing. (KSB)

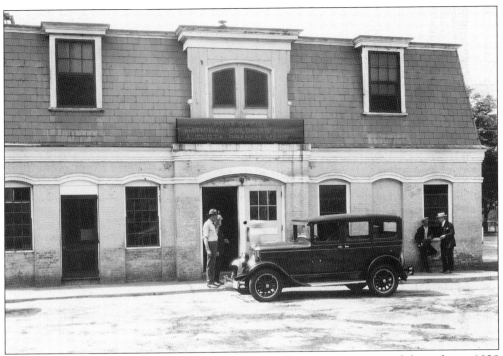

These two men may be discussing the virtues of the shiny Franklin automobile in this *c.* 1928 photograph. Part of the old shoe shop had been converted into the post office. At one time in the 1880s, Togus received and shipped mail three times a day. (KSB)

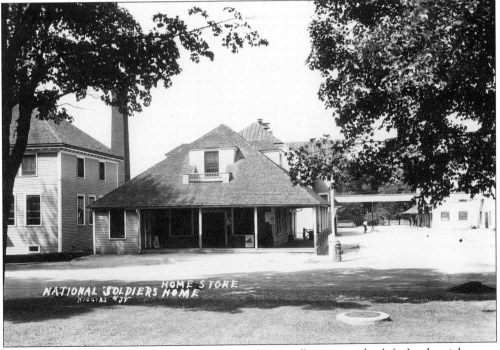

In 1928 the Home Store was located next to the guardhouse, on the left. In the right rear, several residents stand near the entrance to the mess hall. (Lester Higgins Photograph, TL)

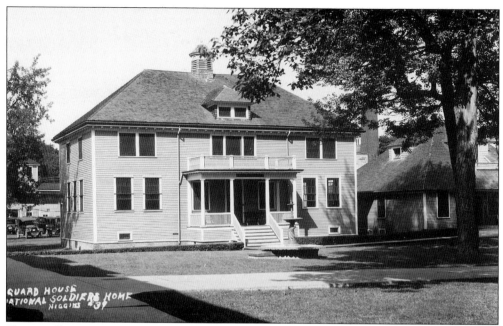

The guardhouse was constructed in 1902 for $7,000. On the first floor were three jail cells, a courtroom, police sergeant's office, a detention room, and two toilets. The second floor was used as the guard barracks. The building on the right is the Home Store in this *c.* 1928 photograph. Parking area for automobiles can been seen on the left. (Lester Higgins Photograph, TL)

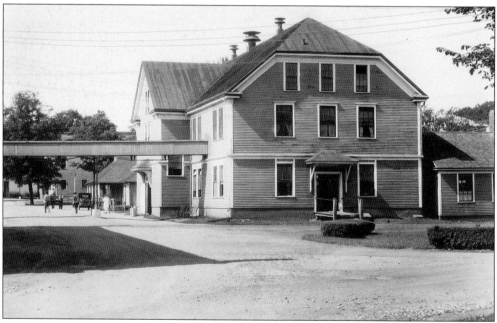

The laundry building stands to the right of the mess hall in this 1928 photograph. In 1912 a dry cleaning plant, managed by Ralph Lizotte of Lewiston, was added to the laundry. The residents of Togus were very pleased with the results of the dry cleaning and steam pressing of their uniforms. (TL)

The piazzas around the four main buildings at Togus were completely rebuilt in 1908, with the third floor added about the same time as seen in this *c.* 1928 photograph. (GW)

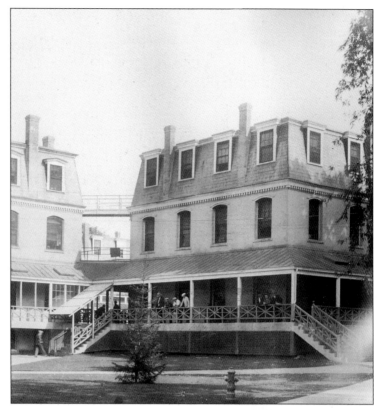

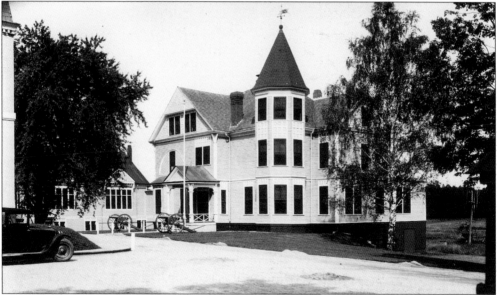

The headquarters building has a different appearance in this *c.* 1928 photograph. The piazza and the porch rockers are gone, replaced by a portico. A flagpole and two Civil War 12-pounders now occupy the front entrance. The appearance of the automobile and the removal of the piazzas at Togus were a reflection of what was happening in the rest of American society in the late 1920s. (TL)

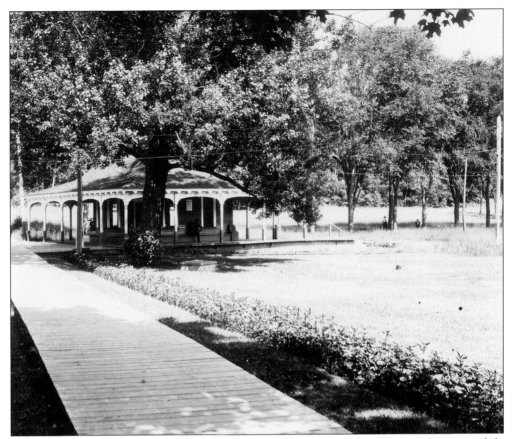

The electric railway station was facing failure by 1928 as Mainers began using the automobile in greater numbers. In about four years, construction would begin on a new brick-and-concrete hospital in the field behind the railway station, the former home of the deer park and zoo. The animals were sold and the park closed in 1917 for economic reasons. (EM)

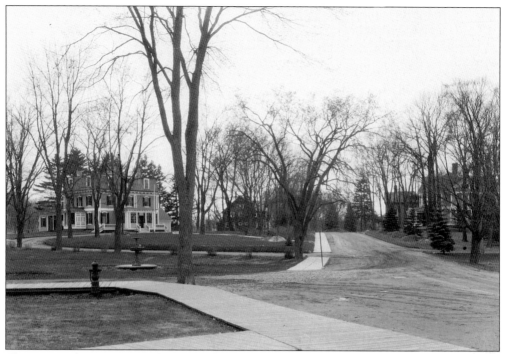

This is an early spring view of the officers quarters at Togus in the 1920s. From left to right they are the residences of the governor, quartermaster, treasurer, and adjutant. In the foreground is one of the 12 hydrants installed by the Augusta Water Company in 1887. (TL)

The treasurer's residence, located on Rockland Avenue just past the governor's residence on the opposite side of the street, was built of brick about 1890. Visitors to Togus during the 1920s enjoyed the landscaping of the officer's residences. (Lester Higgins Photograph, TL)

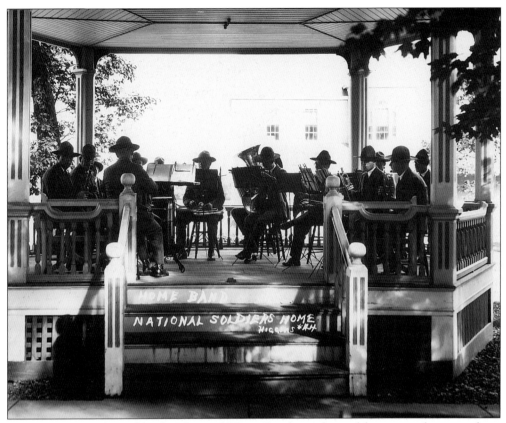

A concert was performed by the National Home Band on a beautiful summer afternoon about 1928. Over the years private citizens had joined the home band. The time required to be in the band may have discouraged the aging veterans from joining, for recruitment for the band was difficult. In 1916, the Board of Managers notified all branches that the home bands could only perform at their respective branches. (Lester Higgins Photograph, TL)

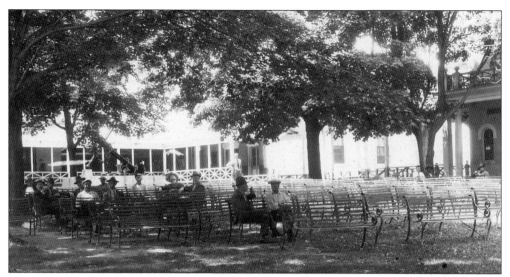

Residents of Togus gather on the benches in front of the bandstand on a summer afternoon about 1928. Behind them is the northern main quadrangle building and on the right is the mess hall. In the background, a large unidentified anchor sits on a concrete base. (EM)

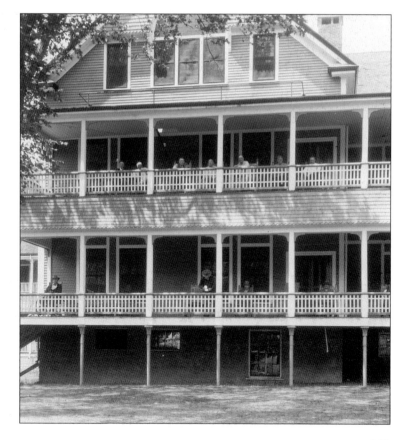

The elderly soldier in the wheelchair on the left of the first floor hospital piazza may be one of about 120 Civil War veterans at Togus at the time of this 1928 photograph. One out of every 20 men in the Union forces had received some form of assistance from the National Home by 1898. (TL)

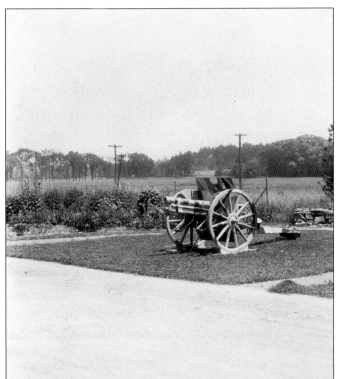

A captured German 77-millimeter field gun was one of the new war relics on display at Togus in 1928. This photograph was taken from Rockland Avenue looking directly east. (Lester Higgins Photograph, KSB)

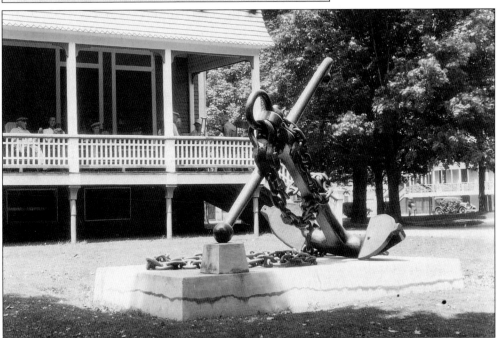

The unidentified anchor was the style and size that was in use on large navel vessels during the Spanish-American War of 1898. The anchor, and another one in the background in the photograph at the top of p. 101, may have been from the battleship *Maine*. No supporting documentation has been found at this time. (TL)

A shield from the bow of the battleship *Kearsarge* decorated a memorial to the veterans of WW I at Togus. A veteran stood at attention while being photographed about 1928. Richard Rowley, a hero of the Civil War battle off the coast of France between the original *Kearsarge* and the Confederate cruiser *Albemanle*, spent many years at Togus. (TL)

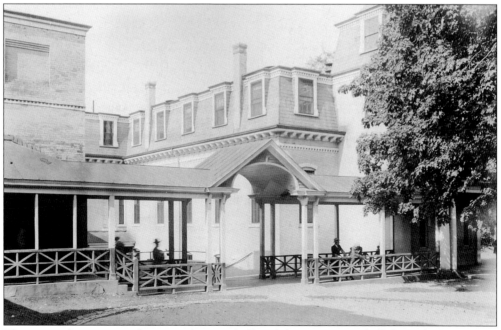

This covered passage way between the mess hall and the amusement hall, later the library, was built about 1908. The portico in the center leads to the WW I memorial featuring the bow shield from the battleship *Kearsarge* in this 1928 photograph. (GW)

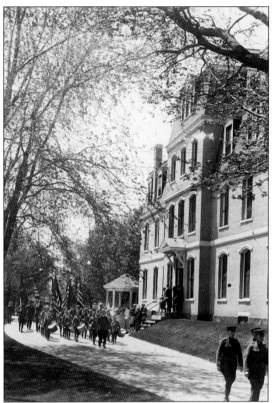

A group of youngsters play the drums in a Memorial Day parade about 1924, as the parade passes the old east-facing main building with the south bandstand in the background. After World War I, the National Homes extended services to women veterans, and female military nurses were included in those able to obtain benefits from the homes in 1928. (EM)

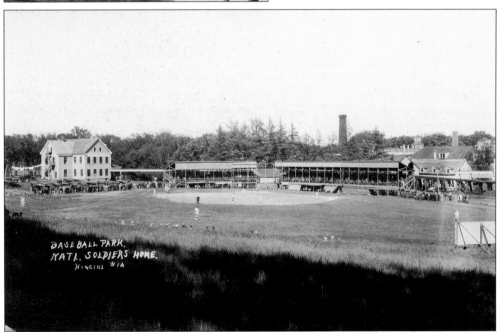

A large crowd has turned out for a game at the Togus baseball park about 1928. The stands are full and fans are standing along the base lines and sitting below the crest of the hill in the outfield. (Lester Higgins Photograph, EM)

Four

From National Home to Veterans Center

1932–1960

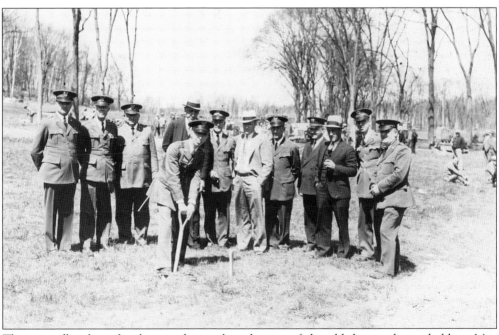

The groundbreaking for the new hospital at the site of the old deer park was held on May 12, 1932. The original caption identifies the participants. Listed from left to right are Major Cloutier, Waltman, Hershey the Chaplain, Ryan (manager), Perkins, Burdell, and Hanly. The third man from the right in the suit and light hat is Harold Gould. (TL)

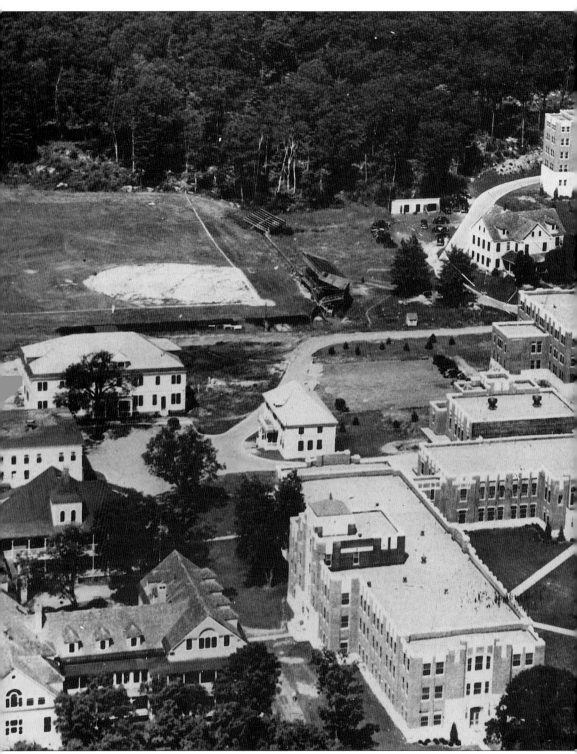

New buildings at Togus in 1936 include the nurses quarters (to the right of the hospital), the hospital administration building, kitchens, and a dining hall. The Ward Memorial Chapel and

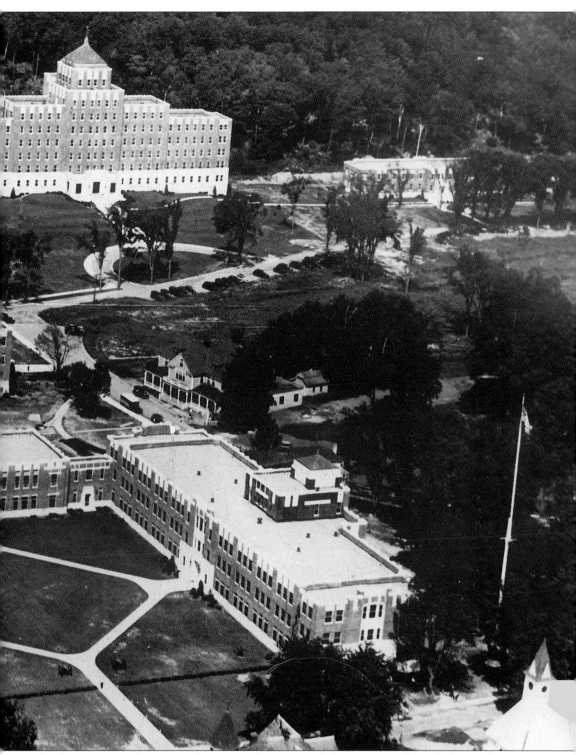

the clubhouse can be seen in the lower right corner, while a portion of the old hospital can be seen in the lower left corner. The Home Hotel is in the center. (MS)

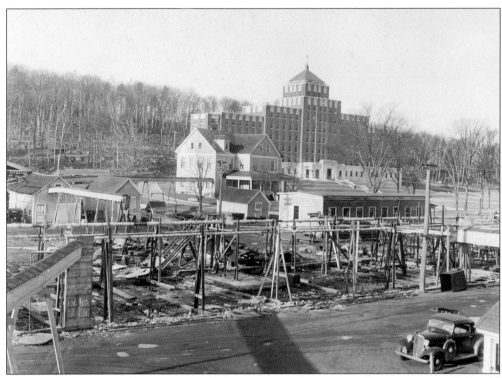

The newly constructed hospital overlooks Togus in the spring of 1934. Many of the old buildings were demolished to make way for modern structures. Only the steam pipes were left standing from the building that previously housed the boiler room and machine and carpenter shops. (TL)

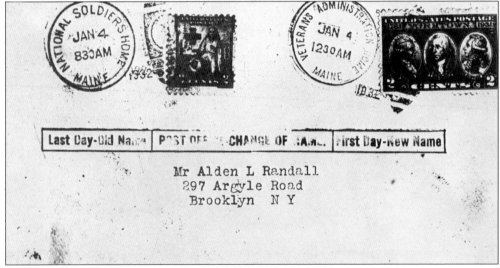

On January 4, 1932, Togus was renamed the Veterans Administration Home, reflecting a change in the philosophy in how to best serve the nation's veterans. (TL)

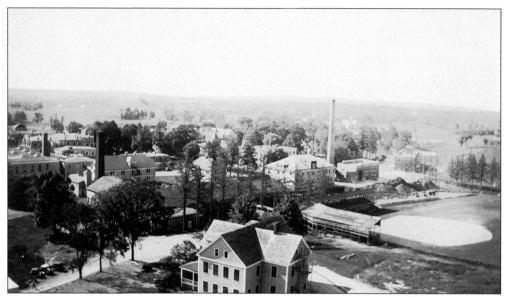

A new heating plant with a towing smoke stack was constructed in 1933 along with a utility building (to the right). They are seen herein a 1934 photograph taken from the new hospital. (GW)

The 1935 Memorial Day services were conducted at the old cemetery on the hill. The monument in the right center of this photograph was built in 1916. (MS)

These children participated in the Memorial Day exercises at Togus on May 30, 1935. In the background can be seen part of an old wooden building that had been demolished. (MS)

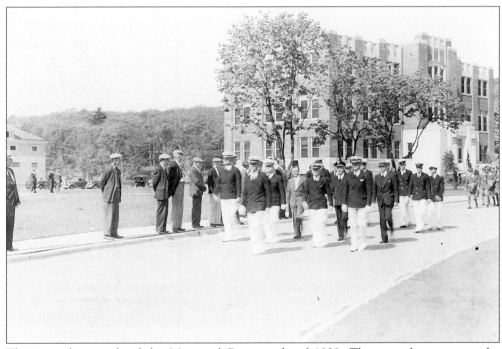

This is a photograph of the Memorial Day parade of 1938. The new theater is in the background. (MS)

The huge, steam-powered pile-driver was working on the foundation site of building No. 207, which became part of the neuropsychiatric hospital in 1937. A large crowd of onlookers is shown here being supplemented by many veterans at the hospital complex windows. (MS)

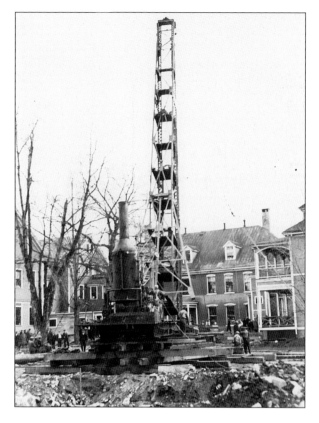

Three residents and two apparent staff members pose in a barracks room on November 30, 1939, two years and one week before Pearl Harbor and WW II, which would bring another generation of Americans to Togus. (TL)

The residence of Governor Stoddard is shown in this March 29, 1935 photograph taken after a Nor'easter dumped wet heavy snow on the area. (MS)

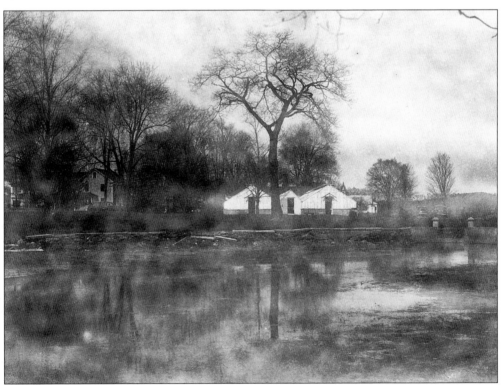

The veterans were able to find serenity at Togus. The duck pond and greenhouses are shown in this 1940s photograph near the south gate. Between 1932 and 1960, over 60 buildings were torn down to be replaced by reinforced concrete and brick-faced buildings. (KSB)

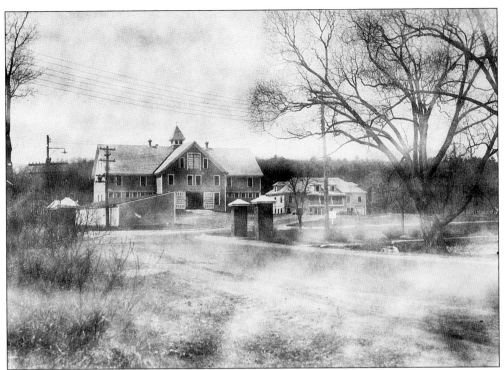

The west gate entrance to Togus from the Hallowell Road has the duck pond situated on the right in this 1940s photograph. The large barn in the foreground was used for sheep and as storage. In the right rear is a large farm building built in 1909 that remains in good condition at Togus today. (KSB)

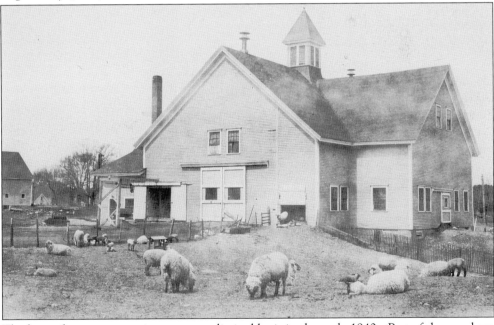

The home farm was operating on a very limited basis in the early 1940s. Part of the cow barn had been converted for use by Coswald breed sheep. (KSB)

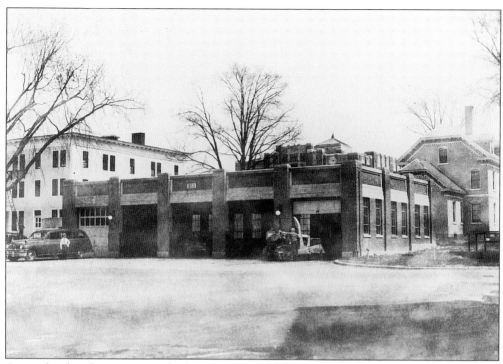

A new five-bay fire station was built at Togus in 1936 at a cost of $20,000. On the left is a late 1940s Packard ambulance. (KSB)

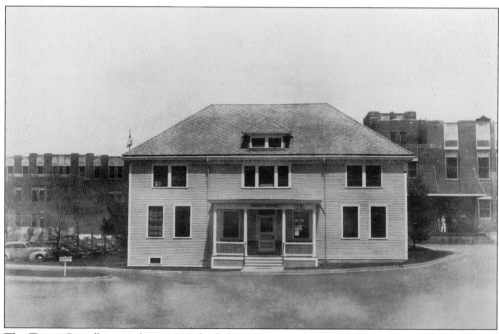

The Togus Guardhouse, about 1948, had the administration building on the right, which was built in 1935. On the left in the KP kitchen and dining room built in 1936. (KSB)

The area where this photograph was taken about 1948 looks much the same today with the exception of the new expansion onto the hospital in the background that was added in 1991. (KSB)

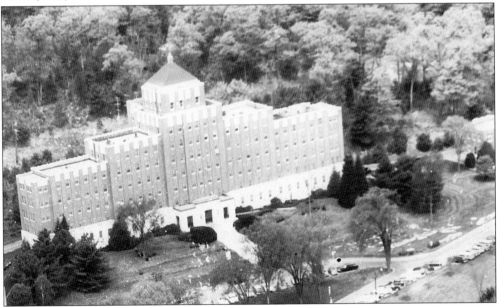

The Veterans Administration Home was changed to the Veterans Administration Center in October 1945, reflecting the new emphasis on providing a wide variety of services to veterans. At this time, the five-story hospital had 305 beds for general medical care, complete with laboratories, an operating room, physical and occupational rehabilitation facilities, and a separate neuropsychiatric building. It was an imposing and architecturally significant art-deco style for Maine. (EM)

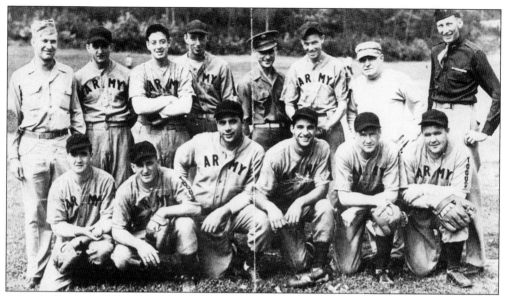

A baseball team was formed at Togus by the 245th U.S. Army Medical Detachment, stationed there during World War II. Pictured and listed from left to right are the following: (front row) Dick Sargent, pitcher; Frank Ignatowicz, pitcher; Tony Girard, first base; Jack Cellucci, center field; Will Osborne, pitcher; and Bill Keraghan, right field; (back row) Teddy Kurtz, special service; Marty Harasmik, left field; Tony Coca, third base; Briggs, catcher; Bob Kasporwitz, shortstop; Orion Wadsworth, outfield; Martin Kennelly, coach; and Lt. Linwood C. Clements, athletic and recreation officer. (RAC)

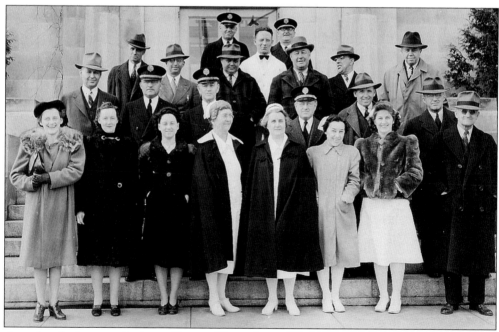

A war bond sales group is pictured here at Togus during World War II. At the top left is Malcolm L. Stoddard, director of the Togus Veterans Administration Center. The group was standing on the front steps of the administration building. (MS)

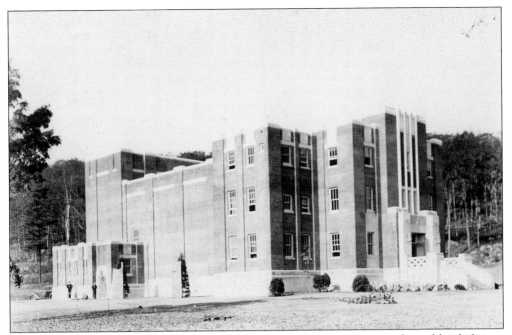

The new theater at Togus was built in 1937 with reinforced concrete and a red brick facing. Theatrical shows, the latest movies, and other forms of entertainment kept the inhabitants well entertained. After World War II, the theater was used for numerous weddings. (MB)

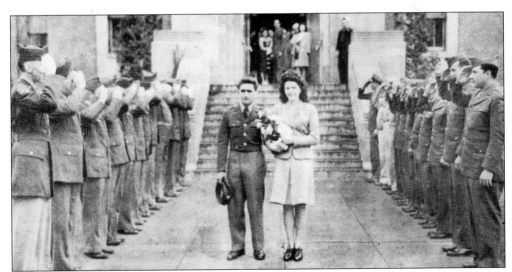

Pfc. Daniel V. LaRocco of 245th Medical Detachment married Miss Lucy M. Merrithew at the Togus Theater on September 2, 1945. This photograph was published in the October 1945 issue of the detachment's newsletter, *The Phoenix*. (MS)

Malcolm L. Stoddard was the first director appointed after the consolidation of all veterans' services at Togus in 1934. Stoddard was a World War I veteran and was wounded in the Argenne area of France. After the war, he was assistant manager of the New England U.S. Veterans Bureau in Boston, and then spent ten years as regional manager of the Veterans Bureau in Portland, Maine. Malcolm Stoddard retired in 1960 after serving 40 years. He stated what he thought was the purpose of the VAC at Togus as follows:

"When a nation engages in hostilities, men with the highest physical and mental rating are selected to serve their country. When these men return they are potential leaders of our communities and every effort is made by the Veterans Administration to rehabilitate these men physically and mentally so they can resume a normal life. They are the most valuable assets which our nation possesses today and no endeavor should be spared to grant them the privileges they deserve—the square deal which is their right, the chance to live as other Americans." (TL)

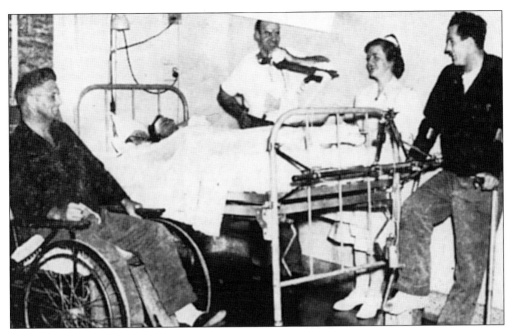

This photograph, which appeared in the *Kennebec Journal* on May 11, 1949, was taken in the orthopedic ward of the Togus General Hospital. Nurse Elva Ingraham chats with patients. Listed from left to right are Wyatt A. Spencer of Bangor, Kenneth Eaton of Millinocket, W.B. Stanhope of Derby, and David M. Webster of Belgrade Lakes. (KJ)

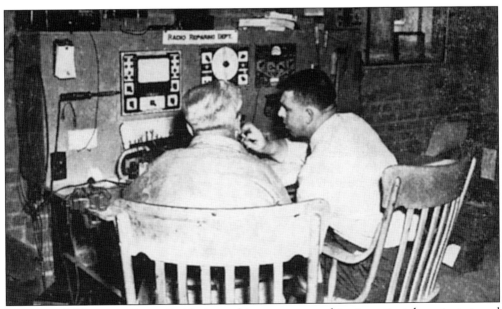

Educational Therapist Oscar Smith is teaching a neuropsychiatric patient how to test and repair broken radios in the radio repair department. Keeping patients active was used in the treatment of mental illness. The neuropsychiatric hospital at Togus had 564 beds in May of 1949. (KJ)

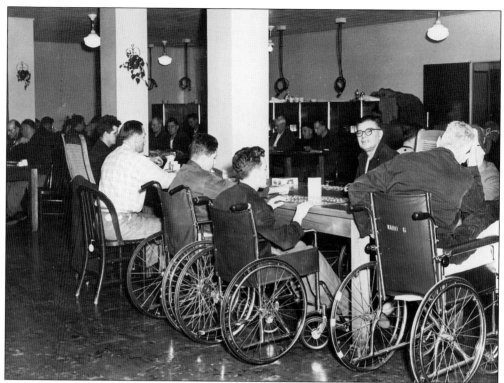

Patients at Togus participate in what appears to be a bingo game in the 1950s. The dining room was used between meals as a recreation area for the many patients who enjoyed the diversions offered. The movies, games, and dances were offered frequently to encourage the patients to interact with other people. (MS)

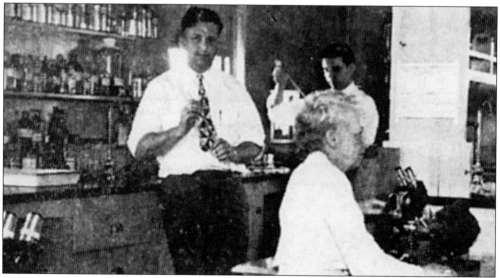

The Togus laboratory personnel in this photograph were performing 7,700 different tests a month in May 1949. There were 15 laboratory workers and technicians at Togus. Pictured from left to right are Benson McFarland, Larry Gervais, chief technician Agnes Hannegan, Gene Lockyer, and Donald Chadwick. (KJ)

Short-wave radio was a popular hobby for many patients at Togus after WW II. (KSB)

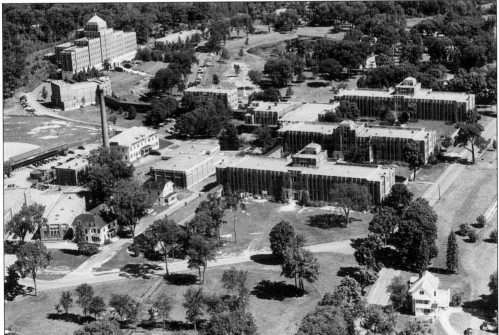

Only four early wooden buildings remained when this photograph was taken in 1953—the quartermaster's building beside the tall smoke stack, the assistant surgeon's quarters, the bandmaster's and chief engineer's duplex, and the surgeon's residence at the lower right. (TL)

The Togus Physical Medicine Rehabilitation Service personnel are here in this 1960 photograph. Listed from left to right are as follows: (front row) Betty Black, Florence Haggard, Dot Jones, unidentified, Joseph Parr, and ? Curtis; (middle row) Henry Weston, Bob Kasporwitz, Huntsman, Charles Farrell, Tom Brigham, Don Frasier, and John Throiver; (back row) Pat Perrino, Wes Reynolds, Charles Bader, Jim Mahaney, Oscar Smith, Paul Mooney, Charlie Funk, Dick Caefer, and Dr. Burnham. (RAC)

A veteran works on a wood lathe in a Togus shop. An opportunity to learn shop skills was felt to greatly enhance the chances of success upon release from Togus in the early 1950s. There were many other occupational training opportunities available for the patients. (TL)

Secretarial and office skills were offered to the veterans as a part of the rehabilitation services. These three men are practicing their typing skills. (MS)

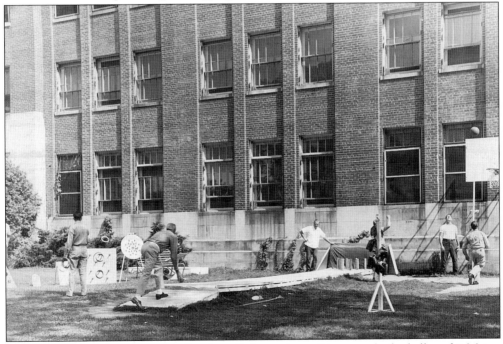

Outdoor games and sports were offered to all the patients. Ring toss, basketball, and a Maine favorite—candlepin bowling—were choices made about 1958. These activities were offered behind building 207. (TL)

In the center of this photograph is an exercise bicycle that appears to be hooked up to a type of speed or mileage recorder. Free weights and boxing were popular ways to workout in the 1950s. The three men in the white shirts are employees of the facility rehabilitation services. From left to right are Charles Bader, unidentified, and Paul Mooney. (TL)

A summer fair in the early 1950s with friends and family provides entertainment and fund-raising for the benefit of the patients. After WW II, many volunteers from the Red Cross, veteran organizations, and other service groups provided volunteer assistance on a regular basis. (TL)

Alfred Waters from Lovell, Maine, is greeted by Reave F. Nichols of Los Angeles, supreme commander of the Military Order of the Cooties, which provided a nationwide assistance program to hospitalized veterans. By his side is Togus Chief Medical Officer Dr. Israel Zeltzeman. (TL)

The new library opened in May 1953. Librarian Dorothy M. Chadwick served until 1960 and the library is presently administrated by another longterm employee, Judy Littlefield. The walls are adorned by a portrait of Longfellow, and two bird's-eye views of Togus—J.B. Bachelder's 1872 lithograph, and A. Rugar's 1878 lithograph (on the far right). (EM)

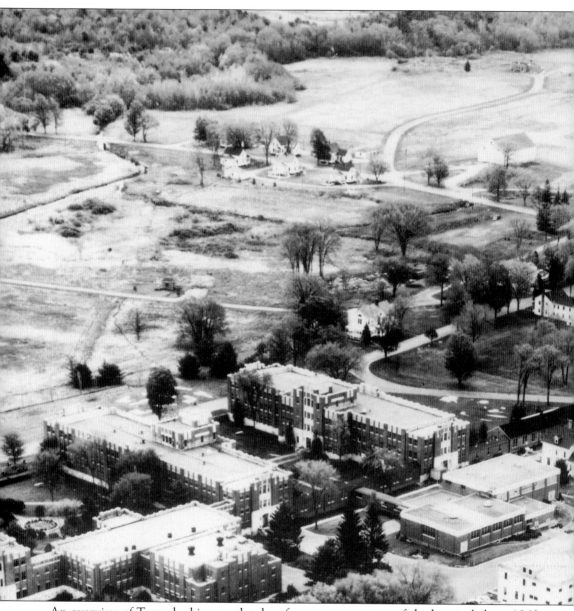

An overview of Togus looking south taken from an upper story of the hospital about 1960. The hospital had nearly 900 beds divided into three units—general medical, surgical, and psychiatric. Frequently occupancy exceeded 90 percent of capacity. Two original buildings, over one hundred years old, can be seen in this photograph. In the center of the photograph

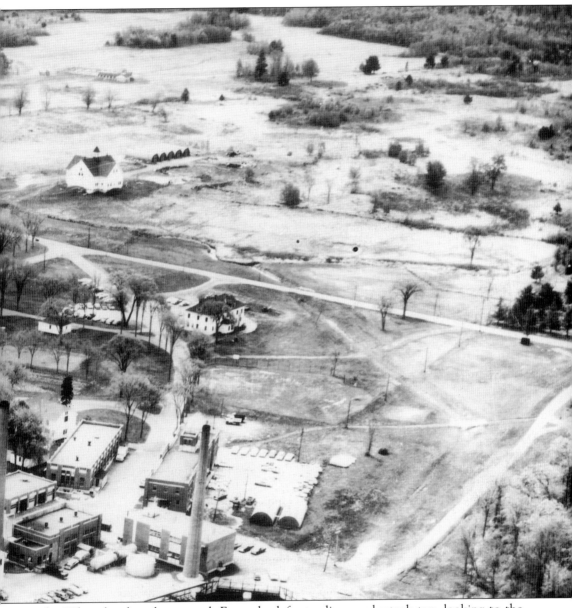

is the White brothers homestead. From the left standing smokestack top, looking to the right, the old bandmaster's and chief engineer's quarters can be seen. Both buildings were once part of Horace Beal's Togus Spring Hotel property, although by 1960 they had been immensely altered. (EM)

Acknowledgments

It is with pleasure and sadness that I thank all the wonderful people who have freely offered their help, advice, expertise, and critiques. I apologize if I have forgotten to include your name.

The majority of the photographs used are from the library of the Togus Veterans Administration Center. Public Affairs Officer James R. Simpson, and Judy Littlefield of library services, were instrumental in allowing me access and providing insight into the operations of Togus. Thank you June Roullard and Gary Pelletier of library services; and John H. Sims Jr., director at Togus, and his secretary Katherine Reay. James Hanlon, residence engineer of Togus, provided a computer overlay of the modern building locations in relation to pre-1900 buildings.

I was fortunate to meet and work with Paul D'Alessandro of the Portland Public Library and Ginny Hopcroft of Bowdoin College's Hawthorne-Longfellow Library. Their knowledge and help were indispensable. Thank you Lillian Fish and the staff at the Maine State Library.

Thank you Earle G. Shettleworth Jr., director of the Maine Historical Preservation Commission, for providing access to the commission's collection and prompt responses to my numerous questions. The M.H.S. was always a source of encouragement and help with any number of requests. Thanks go to Stephanie Philbrick, William Barry, and Nicholas Noyes.

The Kennebec Historical Society in Augusta is an underutilized source of wonderful information on Togus and the Augusta communities. Anthony Drouin, along with Linda Violette and her son Zachery, have valuable knowledge to share.

Most important of all were the wonderful people who allowed me to take their family photographs for an extended period of time. Georgia Wiesendanger, Margaret Stoddard, Marjorie Brown, and Robert and Lillian Kasporwitz can never be thanked enough. Thank you Bedford and Janet Hayes, for allowing the use of a great photograph.

Robert McDonald and J. Emmons Lancaster, who are associated with the Maine Narrow Gauge Railroad and Museum in Portland, allowed me the use of their personal photographs, and with great patience and pleasure provided a fascinating history of narrow-gauge railroading.

Items from the personal collections of Klemens S. Burdzel and Elmore Morgan were outstanding additions to this publication. Thank you both. Several people offered their expertise in the area of dating many of these photographs, including Nathan Lipfert of the Maine Maritime Museum, David Machaiek of the Owls Head Transportation Museum, Nancy Rexford, Sylvia Sherman of the Maine State Archives, and Wil Anderson.

Two special friends from the Augusta area, Roberta A. Cass and Susan Lipman, were always there to lend a hand in securing answers for numerous requests. Roberta's expertise in locating people with photographs of Togus was very beneficial. Susan and daughter Hillary always answered the call, and I thank Hillary for not taking me too seriously.

A heartfelt thank you to Prof. Joel W. Eastman of the U.S.M.'s history department and my academic advisor for his help, advice, and belief in my abilities to make this book happen.

My children, Deborah J. Heath, Tara Lynn Hill, Stanley J., and Scott P. Smith, have been a constant source of encouragement and help. Where would I be without my partner in life, Shirley Ann Coffin Smith? As a wife and friend she has provided me with more support and help than any person could expect. Last, but not least, my granddaughter, Tamarah Robin Smith, who, when she visits always asks, "Is it time to play Grandpa?"

It needs to be acknowledged that any and all errors in this compilation are strictly mine, and no intent was made to misinform or misidentify.

—Timothy L. Smith